Images of Reality, Images of Arcadia

Participating Museums:

Allen Memorial Art Museum, Oberlin College, Oberlin, OH
February 28 – April 23, 1989

The Allentown Art Museum, Allentown, PA
May 28 – August 6, 1989

Bass Museum of Art, Miami Beach, FL
September 1 – October 29, 1989

Crocker Art Museum, Sacramento, CA
November 18, 1989 – January 7, 1990

The Jakob Briner Foundation and the Kunstmuseum, Winterthur special tour:

The Douglas F. Cooley Memorial Gallery, Reed College, Portland, OR
January 26 – March 25, 1990

Meadows Museum, Southern Methodist University, Dallas, TX
April 22 – June 3, 1990

*This exhibition is supported by an indemnity
from the Federal Council on the Arts and Humanities.*

*Special thanks for supporting this exhibition are due
to the following companies and institutions:*

Rieter Holding Ltd., Winterthur
Sulzer Brothers, Winterthur
Swiss Bank Corporation
swissair, Swiss Air Transport Company Ltd.
Volkart Winterthur
Volkart New York, NY, Dallas, TX, Bakersfield, CA
"Winterthur" Swiss Insurance Company and its subsidiary
Republic Financial Services, Inc., Dallas
Pro Helvetia, Art Council of Switzerland
The City of Winterthur

ISBN 3-907798-01-5

Images of Reality, Images of Arcadia

Seventeenth-Century
Netherlandish Paintings
from
Swiss Collections

Margarita Russell

with contributions by
Claude Lapaire
Peter Wegmann
Arthur K. Wheelock Jr.

Exhibition organized by
The Musée d'Art et d'Histoire, Geneva
The Kunstmuseum, Winterthur
The Jakob Briner Foundation, Winterthur
The City of Winterthur

U.S. tour organized by
The Trust for Museum Exhibitions, Washington, D.C.

ACKNOWLEDGEMENTS

It is indeed a happy occasion that the Jakob Briner Foundation, the Kunstmuseum, Winterthur and the Musée d'Art et d'Histoire, Geneva have selected these outstanding Netherlandish paintings of the seventeenth century for the first American exhibition of paintings from their impressive collections. They are testimony to exceptionally important collections and a tribute to a generosity which, shared between the Jakob Briner Foundation, the Kunstmuseum, Winterthur and the Musée d'Art et d'Histoire, Geneva, constitutes a significant contribution to international cultural exchange. The Trust for Museum Exhibitions is honored to present this special collection to American audiences.

The mission of The Trust for Museum Exhibitions is predicated upon the conviction that cultural exchange between nations is a powerful aspect of diplomacy – one which invariably succeeds in building and maintaining essential communication amongst the peoples of the world when other means fail. It is in the cultural realm of international relations that unbreakable bonds are forged, linking nations not only to each other in the present, but also to a shared past and future. *Images of Reality, Images of Arcadia; Netherlandish Paintings from Switzerland* is an important link in this inspired chain.

We are indebted to many individuals in Switzerland and in the United States, without whose assistance this project would not have been possible. The idea for the project was first conceived by the talented curator of the exhibition, Dr. Margarita Russell, who in turn enlisted the unreserved support of Dr. Peter Wegmann, Curator of the Jakob Briner Foundation collection. Soon thereafter, Dr. Claude Lapaire, Director of the Musée d'Art et d'Histoire and Dr. Rudolf Koella, Curator of the Kunstmuseum, Winterthur, became essential and enthusiastic members of the organizing team, which was completed in a most distinguished manner by Herr Urs Widmer, Stadtpräsident of Winterthur, and in the United States by Dr. Arthur Wheelock, Curator of Northern European Baroque Painting at the National Gallery of Art, Washington, DC, and author of the catalogue introduction. Without their tireless efforts from initial selection through the final logistical arrangements, there would have been no exhibition. Working with these exceptional individuals has been a distinct and very special pleasure for The Trust for Museum Exhibitions.

Dr. Wheelock deserves special mention for contributions far above and beyond the call of duty. We extend to him our heartfelt appreciation for the many hours he spent perfecting the selection and reviewing Dr. Russell's admirable text. We take this opportunity also to extend our warmest thanks to the staffs of the participating museums for their able and essential assistance in numerous and complex arrangements for the exhibition tour.

Of course, the permanent record of any exhibition rests with the catalogue and we are eternally grateful to our Swiss colleagues for undertaking the complete production of this lovely volume, and to the catalogue's excellent copy editor, Lois Fern.

Any endeavor such as this exhibition from Switzerland is dependent upon the efforts of those behind the scenes. Once again, the superb staff at The Trust for Museum Exhibitions has worked brilliantly to coordinate every detail of the exhibition and tour in the United States. My deepest appreciation for all their patience and diligence goes to The Trust's Registrar and Administrator, Joan Michaelson, and her assistant, Molly Reams; Liz Stewart, The Trust's Exhibitions Coordinator; my assistant, Maggie Lyons, and my husband, Lewis Townsend, Vice President of The Trust.

Ann Van Devanter Townsend
President, The Trust for Museum Exhibitions

Contents

Dutch and Flemish Paintings in the Musée d'Art et d'Histoire, Geneva 6

 Claude Lapaire

 Director, Musée d'Art et d'Histoire, Geneva

Seventeenth-Century Netherlandish Paintings in Winterthur Museums 12

 Peter Wegmann

 Curator of the Jacob Briner Foundation and the
 Oskar Reinhart Foundation, Winterthur

The Influence of Seventeenth-Century Netherlandish Painting on Swiss Art 17

 Peter Wegmann

Introduction 25

 Arthur K. Wheelock Jr.

 Curator of Northern Baroque Painting,
 National Gallery of Art, Washington, D.C.

Catalogue 29

 Margarita Russell
 Curator of the Exhibition

 Netherlandish Paintings 30
 Swiss Paintings 122

Selected Bibliography 130

Dutch and Flemish Paintings in the Musée d'Art et d'Histoire, Geneva

Claude Lapaire

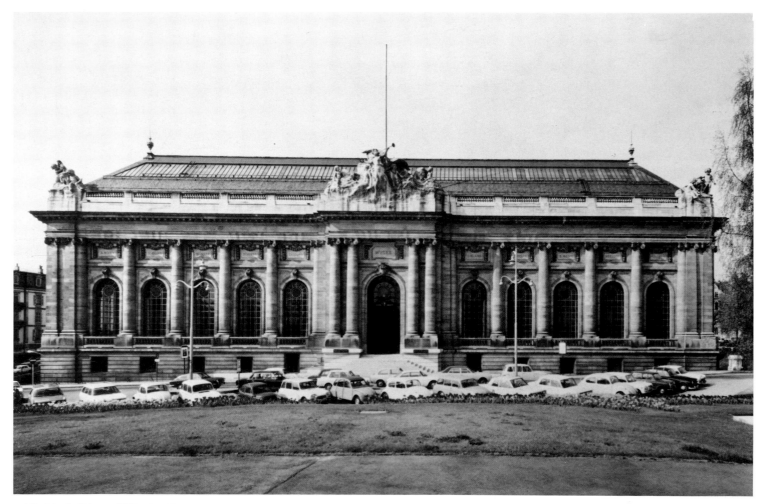

1. *The Musée d'Art et d'Histoire, Geneva*

The Musée d'Art et d'Histoire, inaugurated in 1910, today houses the antiquities, decorative arts, and fine arts collections of the city of Geneva. The museum holdings number over 500,000 objects, among which are 5,000 paintings dating from the medieval to modern period and representing the major European schools of art. Swiss paintings by artists working in Geneva such as Conrad Witz, Jean-Etienne Liotard, Jean-Pierre Saint-Ours, Jacques-Laurent Agasse, François Diday, Alexandre Calame and Ferdinand Hodler occupy a pre-eminent position within the paintings collection. The museum also houses a smaller group of approximately four hundred little-known Dutch and Flemish paintings that have remained largely unstudied by scholars.

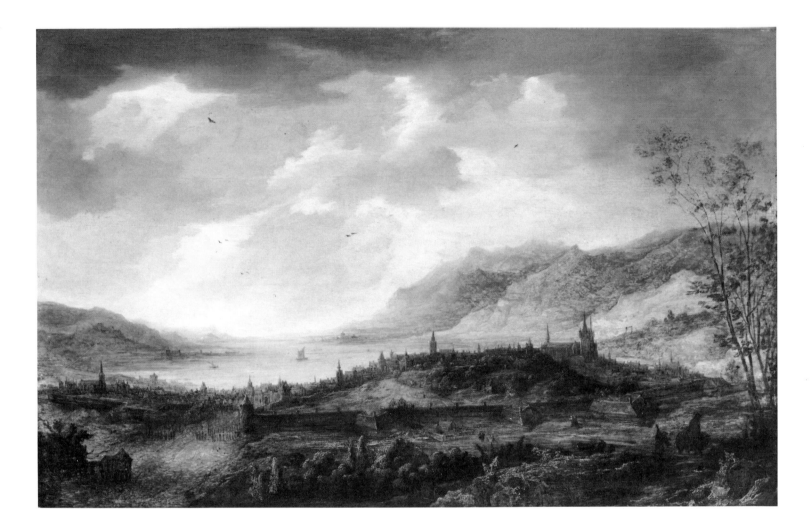

2. Anonymous Flemish master. *View of the City of Geneva.* c. 1630.
(MAH, inv. no. 1974-17)

The interest in paintings from the Low Countries has been active in Geneva since the mid-eighteenth century when numerous connoisseurs assembled large private salon collections. Important works located in major international museums today were once owned by noted Geneva collectors, such as the pastel painter Jean-Etienne Liotard (1702–1789), the banker François Tronchin (1704–1798), and the lawyer Jean-Robert Tronchin (1710–1793). On the eve of the French Revolution over 2,500 Dutch and Flemish paintings are estimated to have hung in Geneva salons.

The Musée Rath built in 1826 was the first Geneva fine arts museum to receive a notable collection of Dutch paintings, including two works by Nicolaes Berchem, *Abraham Regains Sarah from King Abimelech* (cat. no. 6) and *The Prodigal Son* (cat. no. 5) acquired by the Geneva painter

Louis-Auguste Brun in 1791 and bequeathed to the Musée Rath by Guillaume Favre-Bertrand. Other important Dutch paintings include two flower and fruit still-lifes by Jan van Os, bequeathed by Count Jean-Jacques de Sellon, and a still-life by Abraham van Beyeren donated by Fabry de Gex. By 1910, the Musée Rath had received gifts of approximately one hundred Dutch and Flemish paintings, hailing from older Geneva collections; the only work purchased was a portrait by Jan Gossaert in 1872. The large collection assembled by Gustave Revilliod (1817–1890), who owned over two hundred and fifty Dutch and Flemish works that had been formerly exhibited at the Musée Ariana, was donated to the city of Geneva. This collection, comprising masterpieces by Quirijn van Brekelenkam, Elias van den Broeck, Jan Fyt, Juan de Flandes, Pieter de

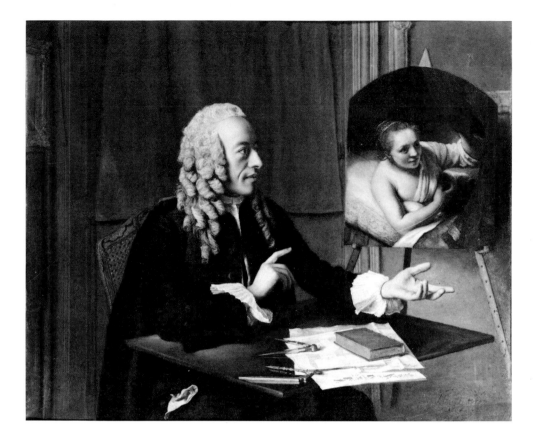

3. Jean-Etienne Liotard. *François Tronchin Viewing the Painting of "A Woman Reclining in her Bed" by Rembrandt.* 1757. Cleveland Art Museum.

4. Jean-Etienne Liotard. Copy on porcelain of Quirijn van Brekelenkam's *Old Woman Sleeping with a Bible.* 1760. (ex. François Tronchin Collection), Kunsthistorisches Museum, Vienna.

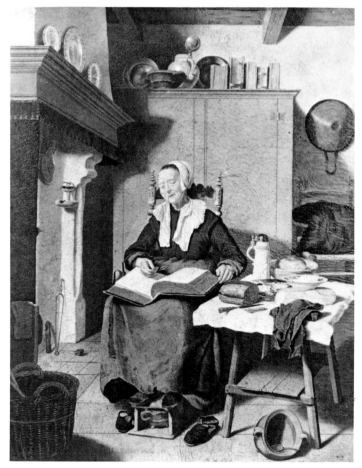

Molijn, Roelandt Savery, Pieter Mulier the Younger (Tempesta) and Rachel Ruysch, later entered the Musée d'Art et d'Histoire.

In 1910 and 1936 the Musée d'Art et d'Histoire received the holdings of the Musée Rath and the Musée Ariana respectively. These donations were further increased by Guillaume Favre's (1874–1942) gift of twenty-two northern paintings from the former Duval collection. Duval, a Geneva goldsmith working in St. Petersburg, owned a superb collection of Dutch paintings, including portraits by Thomas de Keyser and J.A. Ravesteyn (fig. 7), a landscape by Meindert Hobbema, and three landscapes by Philips Wouverman, including one whose provenance was listed as the J.R. Tronchin collection.

5. Alexander Calame. *The Salon of Jean-Gabriel Eynard.* c. 1835. Water-color. (MAH, inv. no. 1963-27)

6. Alphée de Regny. *The Musée Rath, Geneva.* c. 1850. (MAH, inv. no. 1980-271)

The Musée d'Art et d'Histoire did not receive further gifts until 1967 when Louis Baszenger donated twenty works of art. This small collection of fifteenth to seventeenth century Dutch and Flemish works by such artists as Cornelis van Haarlem, Hendrick Avercamp, Jacob de Wet, and Simon Kick, including *The Woman Reeling Yarn* (fig. 10) by an anonymous master of the Delft school, which was attributed to Vermeer by W. Thoré-Bürger in 1866, remains a separate foundation within the Musée d'Art et d'Histoire. The Collection of Netherlandish paintings in the Musée d'Art et d'Histoire has not grown recently, largely owing to the lack of exhibition space. Possible building expansion in

7. Jan Anthonisz van Ravesteyn. *Portrait of Pieter van Veen with his Son and Clerk.* c. 1620. (MAH, inv. no. 1942-22)

8. François Duchastel. *Sister Juliana van Thulden on her Deathbed.* 1654. (MAH, inv. no. 1872-1)

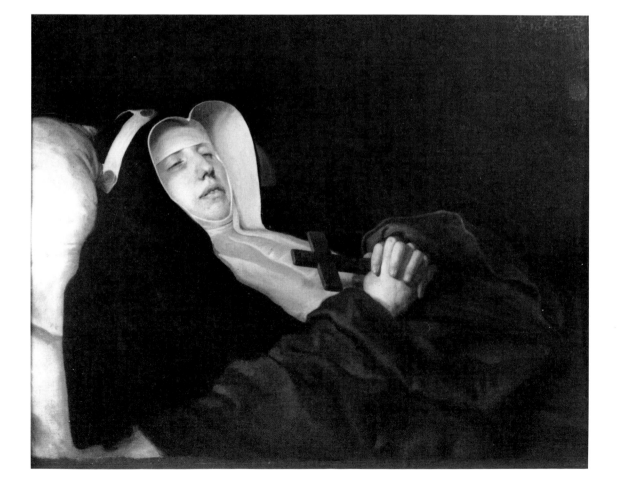

the future will allow for more exhibition space for the display of these paintings. This would be important not only because of their intrinsic value and historical connection with former Geneva collections, but also for a greater understanding of the artistic development of the Swiss school in Geneva, from Liotard to Hodler, as influenced by northern painting.

9. Philips Wouverman. *St. George and the Dragon.* c. 1650. (MAH, inv. no. 1942-29)

10. Delft School (?). *A Woman Reeling Yarn.* (MAH, inv. no. BASZ.3)

SEVENTEENTH-CENTURY NETHERLANDISH PAINTINGS IN WINTERTHUR MUSEUMS

Peter Wegmann

Winterthur today has three museums which house collections of seventeenth-century Netherlandish painting. Of these, the Kunstmuseum and the Jakob Briner Foundation have loaned their more important works to this exhibition.

The history of the Kunstmuseum began in 1848 when a museum association *(Kunstverein)* was established with the purpose of collecting contemporary Swiss art. In 1864, the museum received twenty-four paintings, dating from the sixteenth to the eighteenth century, that had once belonged to the *Kunstkammer,* or art gallery, of the Rheinau convent (see cat. no. 18). This small group of paintings, however, did not have any impact upon the acquisition policy of the Kunstmuseum, which since the turn of the century has been greatly influenced by Winterthur's participation in the mainstream of international modern art, especially in France. Local art patrons, such as Oskar Reinhart and Hedy and Arthur Hahnloser, who had formed important collections in the first half of the century, contributed to the establishment of Winterthur as an important cultural center. Their patronage encouraged the construction of a new museum which opened in 1916 (fig. 2).

Since that time, others have made generous donations to the Kunstmuseum forming a representative collection of European paintings from the Impressionist period onwards. Regretfully, the acute lack of space allows only a small percentage of the collection to be exhibited and this primarily on a temporary basis. The small number of Netherlandish paintings from Rheinau and other provenances which did not fall into the time frame of the Kunstmuseum's collection policy have since been on permanent loan to the Briner Foundation.

Oskar Reinhart (1885–1965), the most important Winterthur collector, opened a part of his private collection to the public in 1951 as the Oskar Reinhart Foundation Museum (Stiftung O. Reinhart). This institution houses approximately 500 paintings from the eighteenth to the twentieth century and represents the German, Swiss, and Austrian schools of art. There is a significant emphasis upon German Romantic painting, with Caspar David Friedrich's well-known *Chalkcliffs of Rügen* a flagship of the collection. After the death of Oskar Reinhart, the remainder of his collection was donated to the Swiss Confederation and an additional museum (Sammlung Oskar Reinhart "Am Römerholz") was opened in his former residence in 1970.[1] This collection includes Old Masters and a group of mainly French nineteenth-century painters, among them notable Impressionists. Reinhart's seventeenth-century Netherlandish paintings are not the core of the collection, but serve as reference points for the development of nineteenth century

1. Kunstmuseum, Winterthur. Interior view with works by Jean Arp, Fernand Léger and Piet Mondrian.

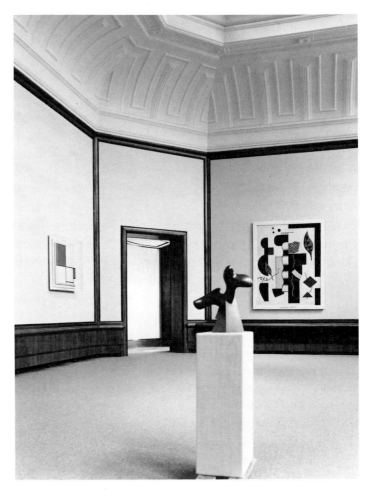

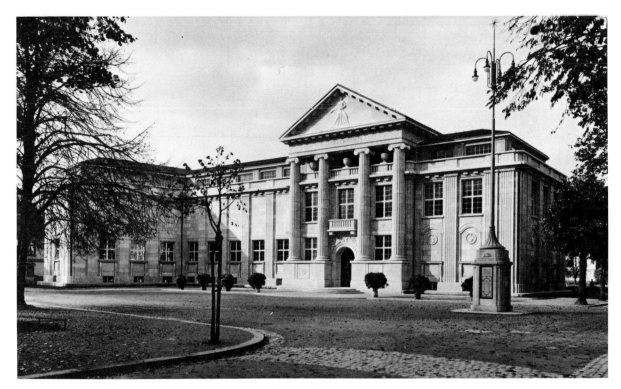

2. Kunstmuseum, Winterthur. Main façade, built by Robert Rittmeyer.

3. Peter Paul Rubens or Jacob Jordaens. *Portrait of a Lady with a Small Dog.* Panel, 98 × 73 cm. The Oskar Reinhart Collection "Am Römerholz," Winterthur.

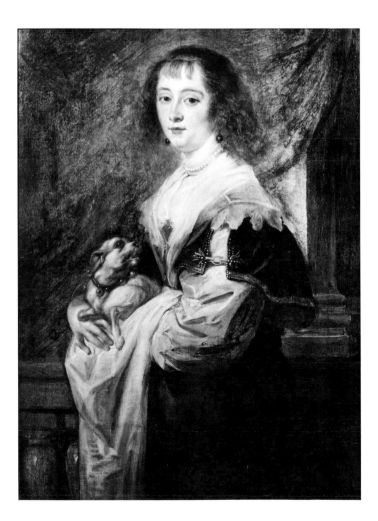

painting. For example, a portrait of an Antwerp patrician by Rubens or Jordaens (fig. 3) is contrasted with a nude by Gustave Courbet, a virtuoso oil study by Rubens for the *Decius Mus* cycle is shown alongside Goya and Delacroix paintings; Frans Hals's *A Boy Reading* is placed next to works by late nineteenth-century painters, who greatly admired the Dutch artist's "impressionistic" technique, and Philips Konincks's *Cityscene on a Mountain Ledge* (fig. 6) is shown with a landscape by John Constable. Other notable Dutch works are a winter landscape by Aert van der Neer (fig. 7), *The Card Players* by Gerard ter Borch (fig. 4), and *The Dream of Jacob* by Aert de Gelder (fig. 5).

Somewhat overshadowed by the three better known Winterthur museums is the smaller Jakob Briner Foundation, with a nucleus of approximately seventy paintings. Jakob Briner (1888–1967), a native of Winterthur, was a customs official by profession and in his spare time assembled various, specialized collections. The inventory of his collection lists over 10,000 objects including prints and engravings, painted fans, and portrait miniatures from the sixteenth to

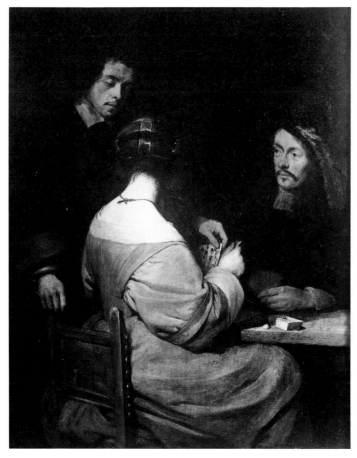

4. Gerard ter Borch. *The Card Players*. Panel, 25 × 20 cm. The Oskar Reinhart Collection "Am Römerholz," Winterthur.

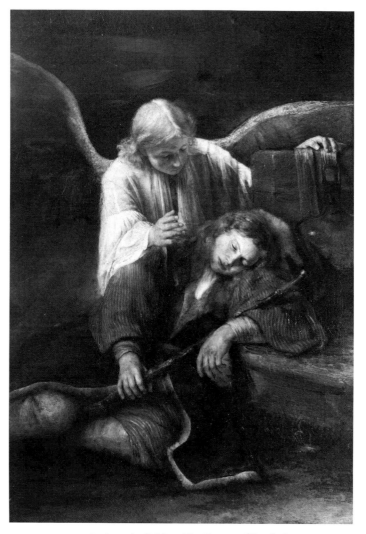

5. Aert de Gelder. *The Dream of Jacob*. Canvas, 172 × 118 cm. The Oskar Reinhart Collection "Am Römerholz," Winterthur.

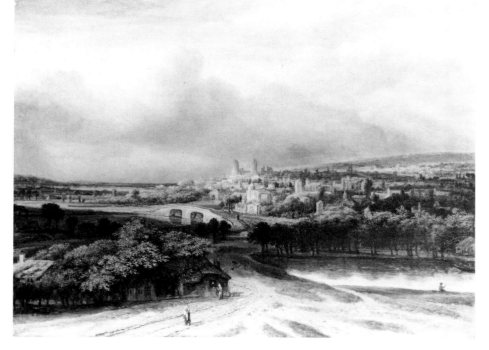

6. Philips Koninck. *View of a Town on a Hillside*. 1651. Canvas, 62 × 86 cm. The Oskar Reinhart Collection "Am Römerholz," Winterthur.

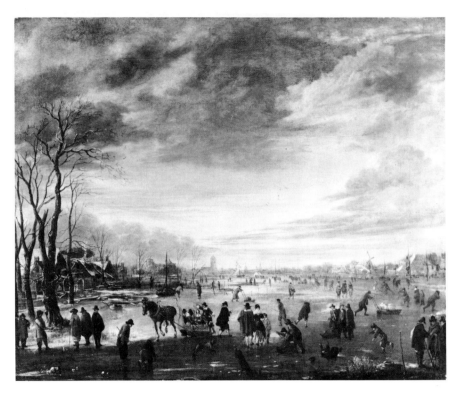

7. Aert van der Neer. *View of a River in Winter.* Canvas, 70 × 84 cm. The Oskar Reinhart Collection "Am Römerholz," Winterthur.

the nineteenth century. Briner also assembled a group of seventeenth-century Netherlandish paintings, usually small in format and rich in detail, concentrating on pictorial themes rather than artists. A 1961 exhibition of his paintings at the Kunstmuseum gave Briner the idea to donate his collection to the city of Winterthur. Owing to the lack of exhibition space at the Kunstmuseum, the Briner collection of paintings and portrait miniatures[2] was established at the renovated city hall (Rathaus), where it has been on display since 1970. The Briner collection was placed together with an important collection of sixteenth to nineteenth-century clocks belonging to the city of Winterthur, but is exhibited in different rooms. Briner left a substantial endowment to his foundation in order to expand the collection. A large number of the paintings in the present exhibition were purchased for the Briner foundation after 1970.

The Winterthur city-hall rooms serve as an ideal historical setting for the Briner paintings because the interior decoration also dates from the Baroque period, while a portion of the Rathaus was formerly designated as a museum. For about two centuries, from 1662, these rooms housed the civic library, including a *Wunderkammer,* or collector's cabinet. Inventories from the period describe the objects

8. Rathaus (city-hall), Winterthur. Main façade, constructed by Johann Ulrich Büchel (1753–1792) in 1781.

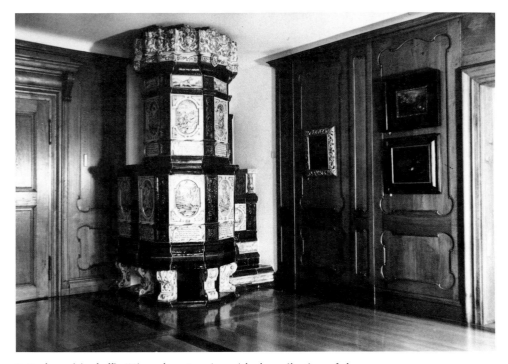

10. Peter Paul Rubens. *Alexander the Great as Jupiter Ammon,* after an antique coin. c. 1606. Ink and bodycolor on card (Jaffé 1977, fig. 311). Jakob Briner Foundation.

9. Rathaus (city-hall), Winterthur. Interior with the collection of the Jakob Briner Foundation, with a fayence tile-stove by David II Pfau, c. 1688.

formerly exhibited in these rooms as a Dutch celestial and terrestrial globe by Blaeu, ancient archaeological finds from the environs of Winterthur, such as Roman bronze statuettes and coins, *naturalia,* and exotic objects. Various types of paintings hung on the walls, for example, portraits of former city mayors, or *Schultheissen* (see cat. no. 47), and Felix Meyer's *View of the Grindelwald Glacier* (cat. no. 50). One of the glories of the city hall *Wunderkammer* was a series of paintings of natives from Southeast Asia, now lost. They were sent to Winterthur in 1667 by Hans Ulrich

Meyer, the brother of painter Felix Meyer, hired as chief surgeon by the Dutch East India Company to practise surgery on the island of Banda. He also shipped back exotic rarities, including shells, lacquer work and rare Japanese scrolls. These are but a few examples of the close historical links established between Switzerland and Holland during the seventeenth century. The *Wunderkammer* was dismantled in the nineteenth century and the objects scattered among various Winterthur museums.

1. The Reinhart Museum "Am Römerholz" was donated to the state on the condition that the paintings would neither be sold, loaned, or added to through purchase or further donations.

2. cf. Stadler 1986

THE INFLUENCE OF SEVENTEENTH-CENTURY NETHERLANDISH PAINTING ON SWISS ART

Peter Wegmann

The Netherlandish paintings shown in this exhibition are complemented with four works by Swiss painters of the seventeenth century, which demonstrate the pervasive influence of Dutch Golden Age painting and underline the close links that existed between Holland and Switzerland. These four paintings, hardly known outside Switzerland, should enrich the exhibition, opening up interesting new aspects of seventeenth-century Northern art.

Over the centuries the Netherlands and Switzerland had many common interests. The river Rhine, Holland's lifeline, linked the two countries, encouraging the development of close commercial ties, but there was also a long tradition of intellectual exchanges. Erasmus of Rotterdam, for instance, lived at times in Basel, where his works were published by the printer Hieronymus Froben. Following the Peace of Westphalia in 1648, which recognized the independence of Holland from Spain and of Switzerland from the Holy Roman Empire, a special friendship bound Holland with Switzerland, particularly with the reformed Swiss cities. The Dutch Reformed Church is indirectly indebted to Switzerland for its religious orientation, which reflects a combination of Calvinism and Zwinglian characteristics rather than Lutherism. In the second half of the sixteenth century the Theological Academy of Geneva, where Calvin held sway, had approximately three hundred registered Netherlandish students. Numerous Swiss students during the seventeenth century studied in Holland, particularly at Leiden, while Dutch students attended the University of Basel. Personal friendships thus established furthered a lively exchange of ideas between the scholars of both nations. The two countries also exchanged military aid. Dutch financial contributions were given to Geneva and Graubunden, while Swiss soldiers served in the Dutch army. In the late seventeenth and eighteenth centuries military cooperation between the two nations increased greatly: Swiss troops in Holland at one time numbered over nine regiments with 21,000 men. Against this background it is not surprising that artistic links were also established between Holland and Switzerland.

Seventeenth-century painting in Switzerland does not present a clear art-historical picture. Various currents, religious, political, and cultural, had a direct impact upon it. The religious division of the Netherlands into Catholic Flanders in the South and the reformed Provinces in the North was one of the factors that produced two divergent schools of painting. Switzerland was likewise divided into Catholic and Reformation areas, with similar results for the development of painting. Numerous artists in the Swiss Catholic regions responded to the new trends from Italy where Swiss artists, mainly from the Tessin (Francesco Borromini, Carlo Maderna, Domenico Fontana), were prominently involved in the development of the new Baroque style. Close artistic ties were also established with France, Southern Germany, and Flanders. The painting for the high altar of the Capuchin church in Solothurn, for instance, was commissioned from the Antwerp painter Gerard Seghers (1591–1651) in 1624.

The reformed, mainly urban, areas, however, suffered the consequences of iconoclasm and the Calvinistic prohibition of images. Geneva, particularly, in the seventeenth century witnessed a virtual standstill of artistic production. In other cities also, such as Zurich, Basel, and Bern, the flourishing arts of the Middle Ages and the Renaissance suffered a decline and change of direction. The altar-piece in Switzerland, as well as in Holland, formerly an important and essential commission, was abandoned. Art shifted to the private sector to serve a demand for the decoration of bourgeois interiors. In contrast to Holland, however, easel painting in Protestant Switzerland played a subordinate role in this development. The rooms of Swiss houses, probably for climatic reasons, were richly appointed with wood panelling; windows featured glass paintings, and a large stove, usually of Winterthur manufacture, clad with richly decorated fayence tiles, provided the focal point of the interior (fig. 1). These stoves often displayed extensive pictorial cycles, mostly illustrating biblical, historical, and allegorical themes, often in emblematic form. The sources for these pictorial displays were illustrated books and emblem books, as well as prints by Netherlandish artists ranging from Maerten van Heemskerck, Maerten de Vos, and

Hendrick Goltzius to Johannes Lingelbach.[1] The explanatory texts, mostly moralizing proverbs, frequently dominated the illustrations. Such unified schemes of interior decoration did not allow much room for paintings. Hence only a few categories of painting were practised in seventeenth-century Switzerland.

Portraiture, the most important category of painting in Switzerland, was based on its own rich tradition – for instance the work of Hans Holbein the Younger – but also responded to Netherlandish trends. Portrait commissions were plentiful: *Schultheissen* (mayors), military commanders, and other officials wanted portraits for display in public places (cat. no. 47), while private citizens commissioned husband-and-wife and family portraits. The most important portrait painters were Samuel Hofmann (fig. 2, 3), who had trained in Amsterdam, and his pupil Conrad Meyer (1618–1689), whose remarkable works also show Dutch influences (fig. 4).

Attempts at developing other categories of painting were rare and tentative. Apart from a few large-scale history paintings, historical and religious themes were more commonly depicted in the decorative arts, particularly in the above mentioned stained-glass and tile work, as well as in prints and engravings. Genre and still-life painting, in contrast to their great popularity in Holland, remained relatively unknown in Switzerland and their small output did not have a particular impact. Evidently there was a lack of patrons and commissions for such works and few

1. Interior of Hans Georg Werdmüller's residence the "Alter Seidenhof" in Zurich, with a fayence tile-stove by Ludwig Pfau, 1620, whose decoration is based on engravings by Hendrick Goltzius and other artists. Swiss National Museum, Zurich.

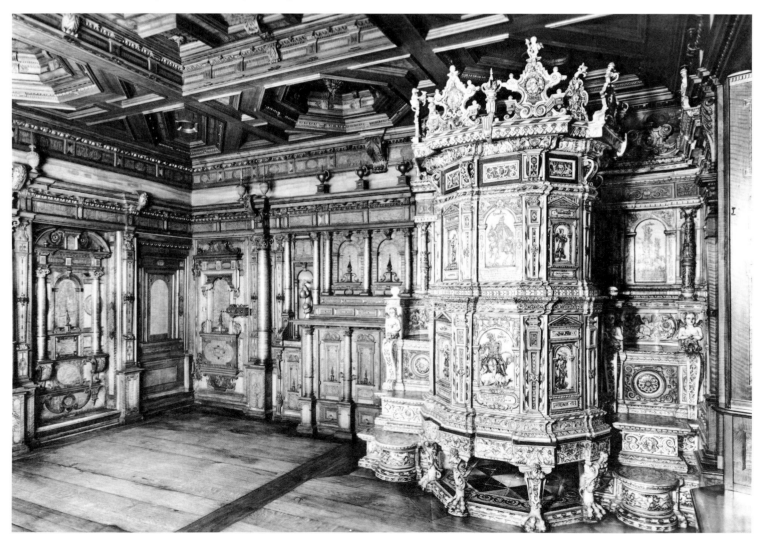

2. Samuel Hofmann. *Portrait of Hans Rudolf Werdmüller.* 1633. Canvas, 214 × 120 cm. Private Collection.

3. Samuel Hofmann. *Portrait of Elisabeth Schmid-Blarer von Wartensee.* 1629. Canvas, 216 × 128 cm. Private Collection.

seventeenth-century Swiss still-life painters were trained specialists in this genre.

The most important still-life painter was Samuel Hofmann, whose paintings, dating from the early 1620s, show the influence of Flemish painting (fig. 5). He relied greatly on Frans Snyders and Jakob van Es in his technique and composition, combining genre figures and still-lifes in his kitchen scenes. Other still-life painters working in Bern in the middle and second half of the seventeenth century, such as Joseph Plepp, Albert Kauw, and Johannes Dünz, were stylistically dependent upon earlier works by Floris van Dijck, Osias Beert, or Georg Flegel. Works by these Bern artists are probably hidden in the flood of anonymous Netherlandish still-lifes, or misattributed to other artists.

Surprisingly, during the seventeenth century, landscape painting was not strongly developed, despite the admiration for Swiss scenery expressed especially by Dutch travellers. The Dutch painter Vincent Laurensz van der Vinne, who spent several months in Geneva working on portrait commissions, wrote in his travel diary: "What I regret most and will always regret is that I travelled through such a marvellous and curious country, with its mountains, crags, waterfalls, rivers, and wonderful vistas, without daring to make drawings."[2] When visiting Switzerland during the peasant

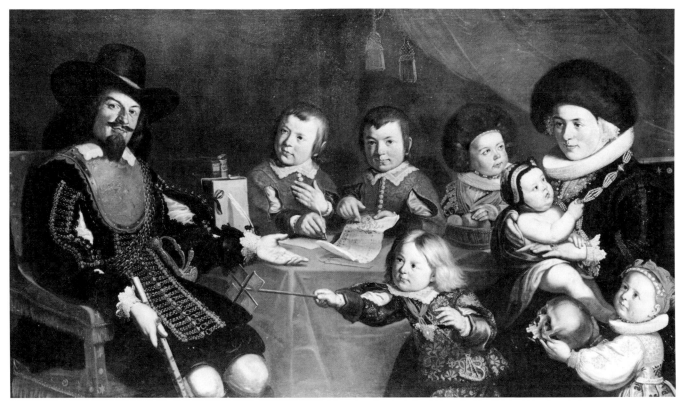

4. Conrad Meyer. *Portrait of Hans Friedrich Peyer-Imthurn and his Family.* 1653. Canvas, 116 × 149 cm. Private Collection.

5. Samuel Hofmann. *Still Life with Dead Game and a Basket of Fruit.* Panel, 75 × 104 cm. Muraltengut, Zurich (Collection of the City of Zurich).

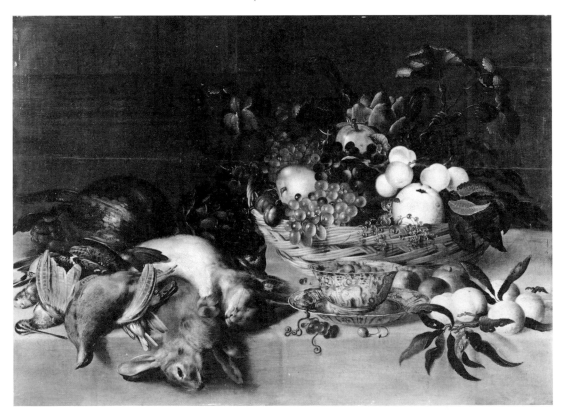

wars of 1653 Van der Vinne was mistaken for a spy and spent three days in prison. After that incident he refrained from drawing in order to avoid further suspicion.

The impulse for pure landscape painting originated in the graphic arts. The Basel printmaker Matthaeus Merian the Elder (1593–1650), a notable engraver, moved to Frankfurt in 1624 where he took over a large workshop, producing numerous topographical scenes and book illustrations. His views of European cities and scenery, published in sixteen volumes, were very popular and influenced many contemporary European artists. The 1642 volume on Switzerland included a representation of the *Rheinfall* (Rhine waterfall) near Schaffhausen (fig. 6). This view attracted the attention of many Dutch people, and between 1621 and 1632 Dutch trading groups considered projects for blasting the waterfall in order to create a navigation link between Lake Constance and Holland.[3]

The Rhine waterfall held a particular fascinatioin not only for Dutch travellers, but also for Dutch artists. Jan Hackaert (1628–after 1685) produced two large-scale drawings of it in 1653 and 1656. It is possible that Jacob van Ruisdael's waterfall scenes (see cat. no. 33) were not exclusively inspired by Allart van Everdingen's Scandinavian motifs, but also by views of the Rhine waterfall. There are two distinc-

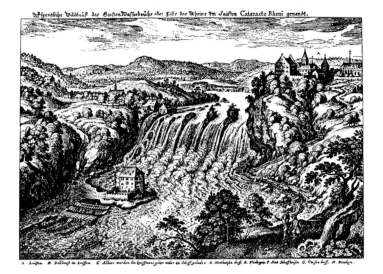

6. Matthaeus Merian the Elder. *The Rheinfall near Schaffhausen*. 1642. Engraving from *Topographia Helvetiae*.

8. Jan Hackaert. *Via Mala*. 1655. Drawing from the *Atlas Van der Hem*. Österreichische Nationalbibliothek, Vienna.

7. Conrad Meyer. *Jan Hackaert and Hans Rudolf Werdmüller Sketching in a Landscape* (detail). 1655. Drawing. Graphische Sammlung, Zentralbibliothek Zurich.

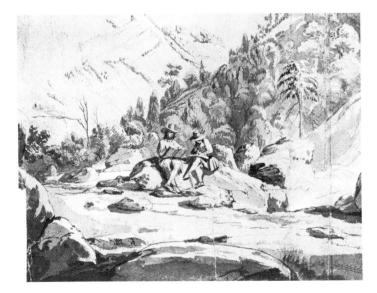

9. Conrad Meyer. *The Lake of Zurich near Herrliberg.* Canvas, 116 × 149 cm. Private Collection.

tive types of waterfall in Ruisdael's work. One depicts a northern view with precipitous, craggy mountains, evergreens, and log cabins; the other, similar to Merian's 1642 vista, features a gentle hilly landscape with leafy trees and buildings, such as a chapel, castles, and timber-frame houses.

Many Dutch artists travelled south to Italy across Switzerland. Unfortunately we know little about the routes the took; however, three itineraries were possible: one crossing France, another through the Tirol, and the third over the Alpine passes in the canton of Graubunden. However, Switzerland was also a travel destination in itself as attested to by Jan Hackaert's visit in 1653, probably undertaken after the death of his teacher, Jan Both (q.v.). His first stay included visits to Basel and Schaffhausen. During his second journey, in March 1655, Hackaert visited Zurich, staying with Hans Georg Werdmüller, a military fortification architect, at his

residence the "Alter Seidenhof" (fig. 1), where he gave drawing lessons to his host's son, Hans Rudolf. In June 1655 Hackaert undertook a study trip through the Alps with his friend, the Zurich painter Conrad Meyer, and the young Werdmüller. The itinerary included the canton of Glarus where Meyer is known to have executed the drawing of Hackaert and Werdmüller sketching (fig. 7). Meyer, the senior and more experienced of the two artists, seems to have introduced Hackaert to the technique of making large-scale panoramic drawings.[4] Hackaert continued his journey alone to Graubunden. He returned to Zurich in September 1655 and stayed in Switzerland until the end of 1657 when he returned to Amsterdam.

Hackaert's journey to Switzerland produced forty-three large topographical drawings, of which forty are included in the thirteenth volume (Helvetia) of maps and views in the collection of the Amsterdam lawyer Laurens van der Hem.

10. Jan Hackaert. *The Lake of Zurich*. c. 1660. Canvas, 82 × 145 cm. Rijksmuseum Amsterdam.

Van der Hem added these prints in 1662 to the most valuable contemporary collection of maps, Joan Blaeu's *Atlas Major*. This work eventually grew to fifty volumes which are now in the Österreichische Nationalbibliothek, Vienna, under the title "Atlas of Prince Eugen."

Hackaert's trip to Switzerland was probably financed by Dutch merchants who wanted documentary illustrations of the Splugenpass, the most important route across the Alps for Dutch travellers.[5] Most of Hackaert's drawings are topographically precise illustrations of the travel route from Zurich to Graubunden, as well as the paths alongside the river Rhine. For example, the narrow and dangerous *Via Mala* is illustrated in detail on eleven folios in order to inform Dutch merchants and travellers of precise road conditions, in particular its viability for carriage traffic and the feasibility of future road expansion (fig. 8). Hackaert's drawings are thus not intended as works of art but as precise topographical documentation serving commercial interests. Nevertheless they are not without aesthetic value.

Unlike Roelandt Savery, who used motifs of Tirolean scenery in several of his paintings (see cat. no. 37), Hackaert did not explore the impressions of his Swiss journey for his subsequent artistic production. After his return to Holland he painted idyllic, Italianate landscapes. Other than a few drawings of imaginary Alpine landscapes, there is only one

painting with a Swiss motif: the most remarkable work of the artist's oeuvre, *The Lake of Zurich,* in the Rijksmuseum, Amsterdam, which had been misidentified until 1972 as the *Trasimeno Lake in the Appenines* on the basis of its representation of an idealized landscape bathed in southern light (fig. 10).[6]

In Switzerland, however, Conrad Meyer's and Hackaert's work did not remain unnoticed. Hackaert left behind in Zurich an album of drawings of fantastic, mountainous landscapes which were copied and studied by other artists. Felix Meyer (see cat. no. 50) was familiar with Hackaert's album and greatly inspired by it. Despite the influence of Dutch Italianate art on his work, especially his etchings, he often included topographical elements in his paintings. He attempted to idealize certain recognizable landscapes by placing them within a classical compositional scheme, similar to Hackaert's rendition of *The Lake of Zurich*.

Hackaert was essentially an accurate topographer who never wandered off the chartered roads and passes, limiting his sketching to populated regions. He never tried to translate his drawings of high Alpine vistas into painting. Felix Meyer, on the other hand, as shown in his *Grindelwald Glacier* (cat. no. 50), penetrated into the solitary wilderness of ice and craggy rocks. An engraving of a lost portrait of the artist at his easel by the Bern portrait painter Johannes

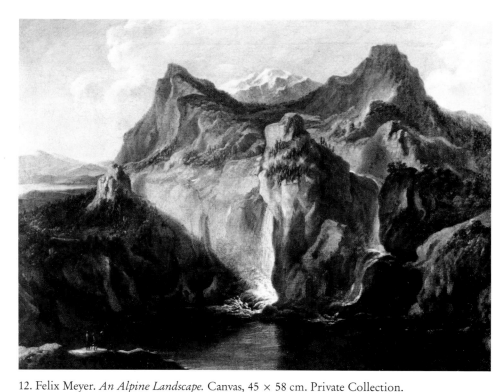

11. Johannes Dünz. *Portrait of Felix Meyer.* Engraving by J.J. Haid, Augsburg.

12. Felix Meyer. *An Alpine Landscape.* Canvas, 45 × 58 cm. Private Collection.

Dünz (fig. 11) depicts the type of Alpine paintings Meyer executed during his sojourn in Bern from c. 1699 to 1703. Meyer's reputation for depicting such motifs appears to have been instrumental in securing the commission from the Bolognese naturalist Count Ferdinando Marsigli in 1703 to record the natural phenomena of the Alps. This scientific interest was the point of departure for the discovery of high Alpine scenery. Meyer had to be familiar with geological and meteorological phenomena, such as rock and cloud formations, rainbows, light effects, and the melting processes of glaciers. In his two surviving Alpine paintings (fig. 12 and cat. no. 50) one sees the germination of a new approach and attitude towards nature: an awe-struck astonishment at the wonders of creation. An enthusiasm for nature evolved that reached its first pictorial apex in the Alpine views by the Swiss painter Caspar Wolf (1735–1783) and culminated in the incomparable Alpine visions of J.M.W. Turner (1775–1851).

1. On the other hand, Swiss engravings were also studied in the Netherlands. Rubens, for example, copied works by Tobias Stimmer and Jost Ammann (see Jaffé 1977, p. 14/15).
2. Stelling-Michaud 1937, p. 13.
3. Solar 1981, p. 15.
4. Bregenz 1984, cat. no. 10.
5. Solar 1981, pp. 16–23.
6. Amsterdam 1987, cat. no. 41.

INTRODUCTION

Arthur K. Wheelock Jr.

This exhibition brings to the United States a fascinating group of seventeenth-century Dutch, Flemish, and Swiss paintings that have never before been seen in this country. Indeed, many of the works are as little known to specialists in the field as they are to the wider public. As in each opportunity we have to see and experience paintings by artists from this period, this exhibition demonstrates the extraordinary richness of their work. In their range of both subject matter and style, moreover, these paintings convey much about cultural attitudes of the period, particularly those of the Dutch school, from which the great majority of the paintings in this exhibition are drawn. This short introductory essay will examine the character of these images by discussing the historical circumstances in which they were created. Specific information about the individual works of art will be found in the catalogue entries.

One of the most remarkable phenomena in the history of the visual arts is the emergence of the Dutch school of painting in the early seventeenth century. The Netherlands had only recently become a political entity and was still suffering from the effects of a long and arduous war against Spain. Nevertheless, from this adversity the Dutch seem to have drawn strength. The realization that this small Republic could successfully achieve its independence from such a powerful country gave to the Dutch an enormous sense of self-esteem. They were proud of their achievements, proud of their land, and intent upon creating a form of government that would provide for themselves a broad and lasting foundation. Aware of their unique social and cultural heritage, the Dutch sought to convey it in their laws, their literature, and their art.

The revolt of the Dutch against Spanish domination during the latter decades of the sixteenth century was led by Prince Willem of Orange (William the Silent) until his assassination in Delft in 1584. Although William had desired to free all of the Netherlands from Spanish control, eventually only the northern seven provinces, Holland, Zeeland, Utrecht, Gelderland, Overijssel, Friesland, and Groningen, agreed to act together to maintain their rights against foreign tyranny. This agreement, signed at the Union of Utrecht in 1579, formed the groundwork for the Republic of the United Netherlands. The southern provinces, which remained under Spanish control, were ruled by regents sent to Brussels by the king of Spain. The northern provinces, wary of a strong centralized government, developed a system that would assure a separation of powers. Military affairs came under the jurisdiction of the Stadholders, who were members of the House of Orange and descendents of William the Silent. Economic and social concerns, however, were under the jurisdiction of the States General, a political body that met in The Hague and was comprised of representatives from the various provinces.

One of the results of this political system was that the various provinces and important cities in the Netherlands retained a great deal of autonomy. While Amsterdam, in the province of Holland, was the largest and most important city in the Netherlands, Haarlem, Rotterdam, Dordrecht, Delft, Leiden, and Utrecht all retained power and prestige. Each of these cities, moreover, was a center of artistic activity, and the style in which an artist worked often reflected the character of the city from which he came. The greatest Dutch artist, Rembrandt van Rijn, for example, who worked for most of his life in Amsterdam, had very little impact in Haarlem, even though that city was no more than fifteen miles distant. Likewise, Frans Hals, the most famous Haarlem artist, did not affect stylistic developments in other Dutch cities. In Flanders, where economic, religious, and political power was concentrated in Brussels and Antwerp, a much more centralized artistic tradition evolved, although in large part this development arose because of the overpowering artistic personality of Peter Paul Rubens. Nevertheless, even in this strikingly different artistic environment a great diversity of styles of painting existed, from the delicate refinement of Jan Brueghel the Elder's still lifes and landscapes (cat. no. 10) to the dramatic seascapes of Bonaventura Peeters (cat. no. 29).

An essential ingredient in the political and social structure of the Dutch Republic was Calvinism. The revolt against Spain was waged for a variety of reasons, not the least of which was religion. The north generally resented the intru-

sion of Spanish Catholicism and favored Protestant beliefs, epitomized by the writings of John Calvin. Protestantism, however, was manifest in many forms. Strict Calvinists, who advocated authority in religious affairs, were supporters of a strong central government and sided with the House of Orange. Those who practiced a milder form of Calvinism, one that tolerated other sects and was more humanistic in its approach, sided with the States General. Tension often existed between the various factions, and religious strife, with direct political ramifications, occasionally surfaced. Not all Dutchmen, however, were Protestant. The Dutch were remarkably tolerant of other religions and the Netherlands became a refuge for Jews, Mennonites, and Catholics who, for one reason or another, fled from their homelands. Among the Catholic emigrees were a large number of artists from Flanders who settled in the north because of its relative prosperity. These artists infused Flemish traditions, particularly landscape, into the north in ways that helped enrich Dutch art.

The political events and religious attitudes of the period are not readily apparent in the wealth of visual material produced by Dutch artists. The still lifes, portraits, landscapes, seascapes, and genre scenes that characterize this school of painting are surprisingly devoid of information on the major occurrences of the day. The most striking way in which the dominant Calvinist influence in the north affected the character of Dutch art is that the church no longer acted as a significant patron for artists. As a comparison of the interior of the Oude Kerk in Delft (cat. no. 43) and the cathedral in Antwerp (cat. no. 25) reveals, no altarpieces and sculptures decorate the Dutch church as they do its Flemish counterpart. Religious subjects, however, were painted in the north even if they were not commissioned by public institutions. Many religious paintings were intended for private worship, as undoubtedly was the case with Cornelis van Poelenburgh's intimate scene of the *Adoration of the Kings* (cat. no. 31).

Whether Catholic or Protestant, the philosophical bases from which Dutch artists worked were clearly the same as those governing decisions in contemporary political, military, and religious spheres of activity. This ideology was essentially threefold: that God's work is evident in the world itself; that, although things in this world are mortal and transitory, no facet of God's creation is too insubstantial to be noticed, valued, or represented; and that the Dutch, like the ancient Israelites, were a chosen people, favored and

blessed by God's protection. These tenets help explain certain basic characteristics of Dutch art that are confusing to contemporary observers. Dutch art is in some respects very realistic. One sees in these paintings views of recognizable towns and buildings (cat. no. 43), portraits of known individuals, still lifes of common items as well as of flowers, shells, and beautiful ceramics (cat. no. 40). In these works artists render effects of light, color, atmosphere, and texture with uncanny skill. Some paintings look so real that the eye is deceived by the illusion. Most of these images, however, are imaginative recreations of nature and not precise records of reality. Often, recognizable buildings are inserted into landscape settings for compositional reasons (cat. no. 4), or flowers that bloom in different seasons of the year are depicted together in one bouquet (cat. no. 34).

The realism of a Dutch or Flemish painting satisfied a desire to view images that conveyed the variety of the visible world. Underlying these realistic images, however, is often a profound moral statement about the nature of that perceived reality. The Dutch, with their ingrained Calvinistic beliefs, were a moralizing people. While they thoroughly enjoyed the sensual pleasures of life, they were aware of the consequences of yielding to its temptations. Pieter Claesz's beautiful still-life in this exhibition (cat. no. 11), for example, depicts a table top on which is displayed a seemingly random array of foods, utensils, glasses, and elegant silver and gold drinking objects. It appears that the meal has been interrupted: the meat pie is half consumed, the lemon is peeled so that the rind hangs over the edge of the table, the pepper is spilling out of the cone of paper, the expensive silver tazza has fallen on its side and the gilt pronk goblet is lying on top of it. This scene, which records so sensitively the various textures and materials of the objects on the table may well have an underlying meaning, however. The arrangement and the type of objects displayed emphasize the transitory nature of a world filled with the sensual and the luxurious. Claesz then seems to comment on this theme by flanking the scene with a whole roll, a glass of wine, and grape leaves, objects that have associations with the meal but also with the eucharist. Their presence thus serves to remind the viewer of Christ's sacrifice and of the importance of temperance in one's conduct.

A crucial component of this basic moralizing quality in Dutch and Flemish realism is the allegorical nature of their view of the world. Just as the bread and wine in Pieter Claesz's still-life painting could represent the eucharist as

well as objects belonging to a Dutch meal, so could the tempest in a dramatic sea painting by Bonaventura Peeters (cat. no. 29) symbolize man's eternal struggle against the forces of nature as well as represent a traumatic common occurence all too familiar to these seafaring people. The deep, brooding energy contained in Jacob van Ruisdael's *Landscape with a Waterfall* (cat. no. 33) likewise draws upon traditional conventions in which flowing water symbolizes the passage of time. A dead tree trunk caught among the jagged rocks in the swift flow of the current is a further reminder of life's mortality. Ruisdael places these themes within a theological context by introducing a church in the middle distance beyond the steeply rising hill on the far side of the calm lake. The most specific reminder of man's mortality in this exhibition is the large depiction of the Tomb of William the Silent in the Nieuwe Kerk in Delft attributed to Emanuel de Witte (cat. no. 44). Here observers stand around the tomb, not only to pay homage to the memory of the father of their country, but also to reflect upon the fact that death comes to us all, even to the great and the powerful.

An aspect of the allegorizing nature of Dutch art that is not found in this exhibition, but that is important to any assessment of the cultural traditions in which these works were created, is the parallel the Dutch drew between their successful revolt against a powerful oppressor and the history of the ancient Israelites. This analogy lent the Dutch struggle against Spain a legitimacy based on historic and heroic precedents. A second parallel, which also became an important element of the national mythology, was drawn between the current political situation and the revolt against the Romans by the Batavians, the ancient forefathers of the Dutch. These allusions to historic events became as intrinsic to the Dutch mythology as the assassination of William the Silent or the heroic defense of Haarlem against the Spanish invaders in 1573. The Dutch also viewed dramas surrounding heroes and heroines, whether mythological or biblical, as allusions to the moral dilemmas inherent in human nature. Thus, while contemporary political, military, and religious events with the exception of naval battles and marine parade pictures were rarely portrayed in Dutch painting, parallel themes rendered in allegorical dress were commonly depicted.

Most paintings that convey these ideas are large works that were commissioned for palaces and public buildings. Many have remained *in situ* and thus are not well represented in collections outside the Netherlands, whether in the United States or Switzerland. These paintings, moreover, were not favored by collectors entranced by the apparent realism of Dutch art since they often contain large-scale, idealized figures, similar in style to Carel Dujardin's imposing depiction of the Crucifixion (cat. no. 14). Such paintings always come as a surprise to viewers used to thinking that large-scale religious and mythological scenes were produced only by the Flemish, Spanish, Italians, and French.

Seventeenth-century Dutch art, like seventeenth-century Dutch culture, stands apart from that of other European nations of the period. The types of subjects artists depicted as well as the stylistic traditions in which they worked derive from a remarkable blend of historic, economic, and religious circumstances. Nevertheless, as this exhibition so amply demonstrates, Dutch artists also travelled extensively. They visited distant lands and became enamoured with foreign landscapes; they met artists who worked in other traditions and learned new modes of expression; and they incorporated their experiences in their paintings. Roelandt Savery went to Prague to work at the Court of Rudolph II, where he painted, among other subjects, landscape views based on his travels through the Tirolean mountains (cat. no. 37). Cornelis van Poelenburgh was one of a large number of artists from Utrecht who travelled to Rome, largely because Utrecht retained strong ties with Italy since it had been the site of an important bishopric. While he was there he became influenced by the small-scale religious scenes on copper painted by the German artist Adam Elsheimer (see cat. no. 31). A number of Dutch artists of a slightly later generation, among them Jan Both (cat. no. 7) and Jan Asselijn (cat. no. 1), must have met the French artist Claude Lorrain, for their light-filled Italianate views, produced after their return to the Netherlands, reflect his vision of the Italian Campagna. Other artists, including Carel Dujardin (cat. no. 14), worked in France, while Herman Saftleven painted views along the Rhine (cat. nos. 35, 36). Even artists who did not travel were not immune to foreign influence. Caspar Netscher, for example, could not have conceived his elegant portrait of a lady in a woodland setting (cat. no. 26) without having seen works by the Flemish artist Anthony van Dyck.

Two basic impulses seem to have determined the character of images created by painters heavily influenced by distant lands or foreign artists. The Dutch were fascinated by the exotic, and harbor scenes populated by turbaned potentates

were extremely popular (see cat. no. 46). Such settings also offered rich possibilities for staging biblical stories, as is evident in Nicolaes Berchem's magnificent paintings in this exhibition (cat. nos. 5, 6). The other impulse was to convey the idyllic, arcadian character of these distant lands, an impulse best demonstrated here in the Italianate landscapes of Jan Asselijn (cat. no. 1) and Jan Both (cat. no. 7).

The fascination with arcadia, however, was not confined to idealized images of Italy. It also strongly affected the types of representations the Dutch and Flemish made of their own land. Izaak van Oosten's *Village Scene* (cat. no. 27) conveys a sense of prosperity and abundance in the life of this small village. Boats in the foreground suggest the ease of transport that the rivers and canals throughout this region provided; peasants walk along with baskets full, while chickens and cows peacefully graze nearby. The importance of shipping is even more evident in the serene marine paintings by Willem Hermansz Van Diest (cat. no. 13) and the younger Willem Van de Velde (cat. no. 42), while Ludolf Bakhuizen, in one of the most remarkable paintings in the exhibition, depicts the equivalent of a nautical bacchanal as nude swimmers frolic in a river while drinking and eating their picnic (cat. no. 3).

No exhibition can show all aspects of this remarkable period of art, and it should be emphasized that Dutch art cannot be fully assessed without taking into account the towering achievements of Rembrandt, Frans Hals, and Johannes Vermeer, nor Flemish art the works of Rubens, Van Dyck, and Jacob Jordaens. What we see here, however, is that a great many talented artists worked alongside these great masters. They explored all aspects of their world and introduced into their images ideas that convey much about the nature of their society. The impact of their work has been felt throughout northern Europe and even in America. As is clear from this exhibition, one of the first foreigners to draw upon Dutch portrait traditions was the Swiss artist Samuel Hofmann (cat. nos. 47, 48, 49). As early as the 1630s he was producing bold and forceful portraits that reflect the impact of paintings by Dutch artists of that period. Similarly, Felix Meyer (cat. no. 50), much later in the century, brought to his remarkable landscape vistas that fusion of realism and fantasy that characterizes so many Dutch landscapes.

CATALOGUE

Margarita Russell

Painters from the Low Countries

Jan Asselijn	cat. no. 1	Michiel van Musscher	cat. no. 24
Hendrick Avercamp	cat. no. 2	Pieter Neeffs the Elder	cat. no. 25
Ludolf Bakhuizen	cat. no. 3	Caspar Netscher	cat. no. 26
Anthonie Beerstraten	cat. no. 4	Izaak van Oosten	cat. no. 27
Nicolaes Berchem	cat. nos. 5, 6	Adriaen van Ostade	cat. no. 28
Jan Both	cat. no. 7	Bonaventura Peeters	cat. no. 29
Quirijn van Brekelenkam	cat. no. 8	Egbert van der Poel	cat. no. 30
Elias van den Broeck	cat. no. 9	Cornelis van Poelenburgh	cat. no. 31
Jan Brueghel the Elder	cat. no. 10	Pieter Gerritsz van Roestraten	cat. no. 32
Pieter Claesz	cat. no. 11	Jacob van Ruisdael	cat. no. 33
Pieter Codde	cat. no. 12	Rachel Ruysch	cat. no. 34
Willem Hermansz van Diest	cat. no. 13	Herman Saftleven	cat. nos. 35, 36
Carel Dujardin	cat. no. 14	Roelandt Savery	cat. no. 37
Jan van Goyen	cat. no. 15	Hendrick Sorgh	cat. nos. 38, 39
Meindert Hobbema	cat. no. 16	Juriaen van Streeck	cat. no. 40
Pieter de Hooch	cat. no. 17	Esaias van de Velde	cat. no. 41
Jan van Kessel	cat. no. 18	Willem van de Velde the Younger	cat. no. 42
Thomas de Keyser	cat. no. 19	Hendrick van Vliet	cat. no. 43
Claes Molenaer	cat. no. 20	Emanuel de Witte	cat. no. 44
Pieter de Molijn	cat. nos. 21, 22	Philips Wouverman	cat. no. 45
Emanuel Murant	cat. no. 23	Thomas Wijck	cat. no. 46

Swiss Painters in the Netherlandish Tradition

Samuel Hofmann	cat. nos. 47–49	Felix Meyer	cat. no. 50

JAN ASSELIJN

Dutch, c. 1615–1652

Born in Diemen near Amsterdam, Jan Asselijn probably studied with Jan Martszen the Younger, a pupil of Esaias van de Velde. After c. 1635 he spent a few years in Rome, where he was influenced by Pieter van Laer and Claude Lorrain. Following a stay in Lyon and Paris, Asselijn settled in Amsterdam. There he became one of the most prominent masters of the Italianate school of Dutch seventeenth-century landscape painting, inspiring Nicolaes Berchem, Aelbert Cuyp, Adam Pynacker and others. A deformity of his left hand prompted his nickname, Crabbetje ("Little Crab"). He was a friend of Rembrandt, who made a fine portrait etching of him in 1647.

1. Southern Port at Sunset

Signed on a rock on the right: *JA* (in ligature)
Canvas, 38 × 50 cm
Jakob Briner Foundation, Winterthur
Provenance: Christie's, London, 17 December 1982, lot 103; Galerie Sanct Lucas, Vienna, cat. 1983/84, no. 14; acquired 1988
Exhibitions: Salzburg/Vienna 1986, no. 5, p. 29

Jan Asselijn introduced to Dutch painting the subject of the Italianate harbor scene, which had a special appeal in the second half of the seventeenth century. This work, painted in the late 1640s,[1] is one of the early examples of the genre. With its glowing evening sky, reminiscent of Claude Lorrain, the exotic architecture and the carefully integrated staffage, Asselijn evokes a nostalgic vista of southern shores. The figure of a young boy catching crabs in the shallow puddles left by the outgoing tide (lower right) may be a reference to the artist's nickname, Crabbetje.[2] This realistically observed stretch of beach and the emphasis on horizontal elements in the composition, with its wide expanses of empty sky, asserts the Dutch character of the painting in spite of its exotic motif.

1. Renate Trnek dates the picture c. 1647 because of its affinity with the Italianate harbor scene in Schwerin, painted in that year. See Salzburg/Vienna 1986, p. 30.

2. Wegmann (forthcoming).

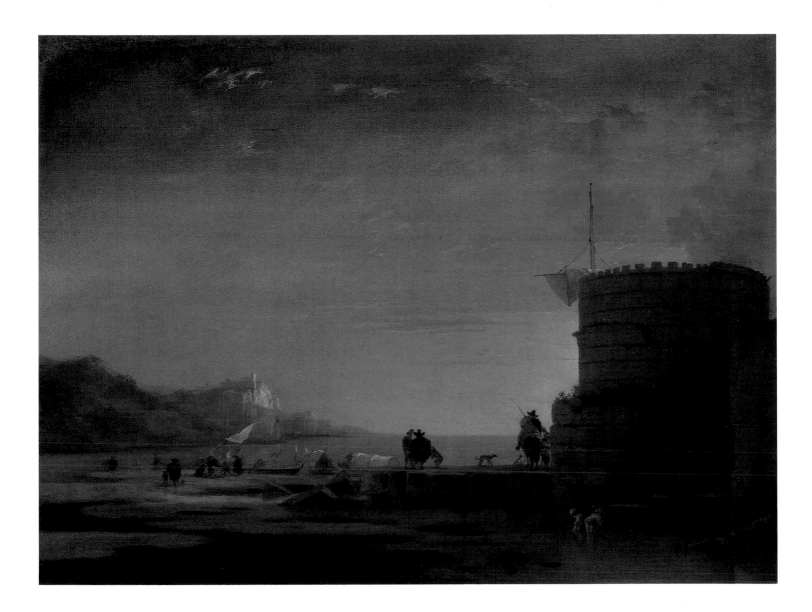

HENDRICK AVERCAMP

Dutch, 1585–1635

Born in Amsterdam, Hendrick Avercamp grew up and spent most of his life in Kampen, a remote town east of the Zuider Zee. His father was the town's apothecary. Hendrick, known as "the Mute of Kampen", must have been deaf as well as dumb since these two conditions usually go together. He was apprenticed to Pieter Isaacsz in Amsterdam, where he is documented in 1607. By 1613 Hendrick had settled in Kampen. Avercamp specialized in painting winter scenes with many figures skating on the ice. These show the influence of David Vinckboons, but also recall genre scenes by earlier Flemish masters, particularly Pieter Bruegel the Elder and Hans Bol. His many drawings of figures, often handcolored, are close to similar graphic works by Adriaen van de Venne. Though traditional in his motifs, Avercamp developed a sensitive feeling for light and atmosphere. Some of his watercolors are pure landscape or seascape. These, and his mature paintings, can be counted amongst the pioneering works of the emerging school of Dutch seventeenth-century landscape painting.

2. *Winter Scene at Ijsselmuiden*

Panel, 47 × 73 cm
Geneva, Musée d'Art et d'Histoire, inv. no. Basz. 4
Provenance: Collection Van Diemen, Amsterdam, before 1675(?); Count Raffaello Mansi, Lucca; Lucien Baszanger, Geneva; bequeathed to the Musée d'Art et d'Histoire, 1967
Literature: Welcker 1979, 88–89, 211, 214, cat. no. S59; Réau 1950, 48–49, 72; Brulhart 1978, n.p.
Exhibitions: Zurich 1947; Delft 1953, no. 5; Zurich 1953, no. 8; Rome/Milan 1954, no. 6; Geneva 1954, no. 12; Geneva 1955, no. 2; Amsterdam 1982; Basel 1987, no. 5

This early work by Avercamp, painted c. 1607/08, contains a multitude of colorful figures engaged in skating, playing *kolf*,[1] or strolling on the bank of the frozen canal. A peat boat, of the type commonly known in Friesland as a *pot,* is frozen into the ice and laborers are seen carrying some of its cargo into a building on the right.[2] The church in the center of the composition identifies the village as that of Ijsselmuiden, which is situated on the bank of the river opposite Kampen.

The picture, with its lively genre interest, is firmly rooted in the Flemish tradition and shows common features with other early skating scenes by Avercamp, such as *Skaters near a Castle* (London, National Gallery) or the skating scene in the Staatliche Museum, Schwerin (Welcker, cat. no. S 73).

1. The Dutch seventeenth-century sport *kolf,* not to be confused with golf, was the forerunner of ice hockey.

2. The building has been tentatively identified as the *Hooge Huis,* an ancient patrician house in Ijsselmuiden. See Basel 1987, p. 64, n. 6.

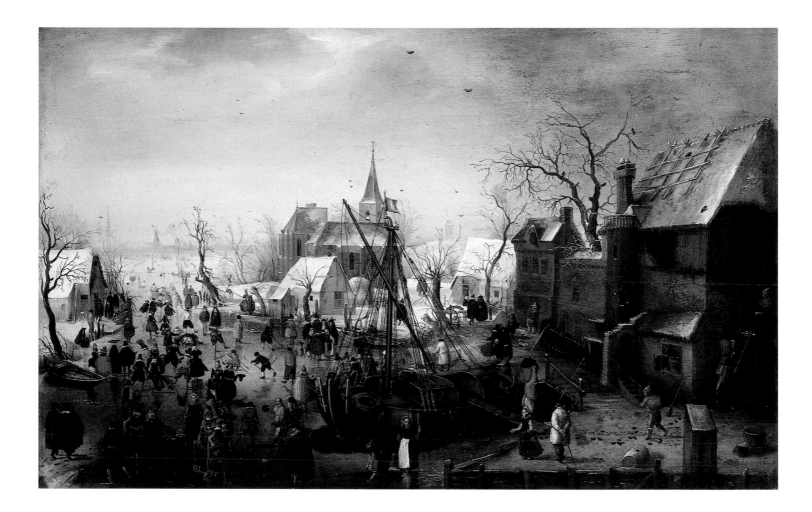

LUDOLF BAKHUIZEN

Dutch, 1631–1708

*B*orn in Emden, East Friesland, Ludolf Bakhuizen lived in Amsterdam from 1649. His first artistic activity was as a calligrapher and draftsman. He studied marine painting with Allart van Everdingen and Hendrick Dubbels and became a member of the Guild of St. Luke in 1663. After the departure of the Willem van de Veldes for England in 1672, Bakhuizen became the leading Dutch marine painter. He was also active as a portraitist and produced a number of ship etchings and "grisailles" (pen paintings).

3. River Scene with Revellers Bathing by a Yacht

Signed on the flag: *L B*
Canvas, 49 × 54 cm
Jakob Briner Foundation, Winterthur (on loan)
Provenance: Comte F. de Robiano, sale Brussels, 1 May 1837, lot 17; Comte de Cornélissen, sale Brussels, 11 May 1857, lot 2; Christie's, London, 11 April 1986, lot 17
Literature: Hofstede de Groot, vol. 7 (1918), no. 168

The painting shows a group of nude bathers drinking, wrestling, and frolicking in the water next to a finely drawn bezan-rigged yacht. The hatch cover, apparently taken from the yacht, serves as a table top, holding drinks and a picnic. Some of the nude revellers are still aboard the yacht where the discarded clothes are piled up. On the opposite bank of the river, a village with its church is silhouetted against a sky with heavy clouds, characteristic of Bakhuizen.

The subject is unique not only in the artist's oeuvre but in Dutch seventeenth-century painting. Although nude bathers figure in other artists' marine paintings, they are usually men engaged in swimming or wading in the water.[1] A similar bathing scene is *La Baignade* (Louvre, no. R.F. 2132), there attributed to Nicolaes Maes.[2] Bakhuizen occasionally painted nude figures in a traditional allegorical context.[3] The present scene, however, with its convincing realism, shows no trace of allegorical or mythological allusions. The painting should stimulate further study for both its art historical and cultural implications.

1. Examples of nude bathers free of allegorical or literary references occur in pictures by Reyer Claesz Suycker, Johannes Lingelbach, Philips Wouvermans, Hendrick ten Oever, Paulus Potter, Michiel Sweerts, and others.

2. The attribution, made by Hofsteede de Groot, can hardly be sustained.
3. For instance, the designs for a title page dated 1698 (see Amsterdam/Emden 1985, cat. nos. T26, T26a, and ill., p. 110).

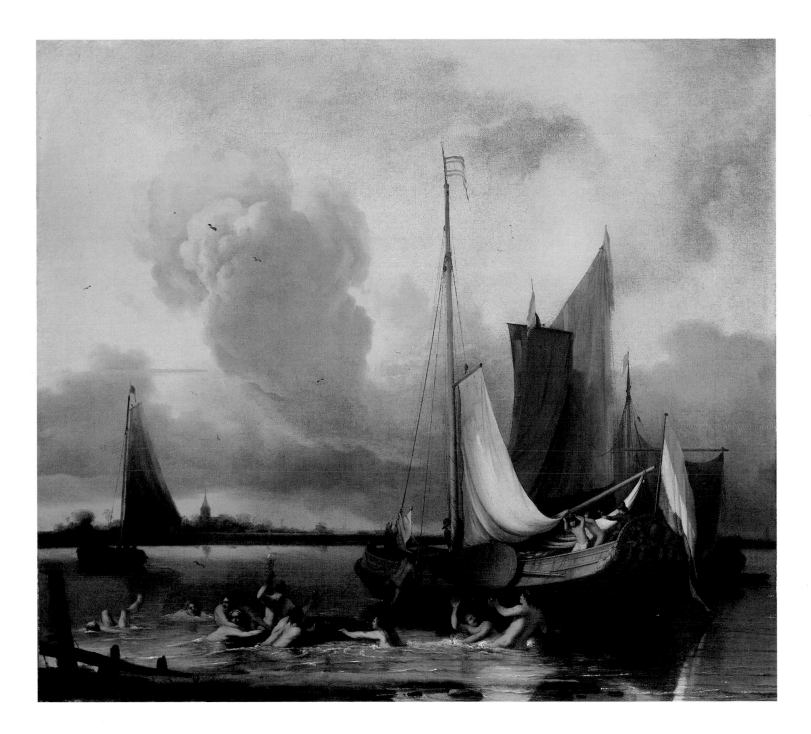

ANTHONIE BEERSTRATEN

Dutch, active 1675–1699

B eerstraten, in a variety of spellings, was the name of a family of marine painters in Amsterdam whose most prominent member was Jan Abrahamsz Beerstraten (1622–1666). Two members of the family, Abraham and Anthonie, probably brothers of Jan, signed their name with the initial A. The similiarity in signatures has led to confusion in attributions, but stylistic differences distinguish Anthonie's paintings from Abraham's. Abraham's style, which features heavy clouds, atmosphere, and solid forms, is close to that of Jan Abrahamsz. Anthonie's brushwork is lighter, and his paintings have a certain brittle clarity, with little atmosphere. Like many other Dutch marine painters, the Beerstratens also produced winter landscapes, often with identifiable topographical motifs, such as castles and churches. Anthonie's winter landscapes are done in an easily recognizable style that harks back to Flemish winter scenes by Pieter Bruegel the Elder and his followers.

4. Village in Winter

Signed lower left: *A. Beer-Straaten*
Canvas, 95 × 131 cm
Geneva, Musée d'Art et d'Histoire, inv. no. 1921-6
Provenance: Collection de Pau-Faesch, Geneva; bequeathed to the Musée d'Art et d'Histoire, 1921
Literature: De Geer 1915, p. 126; Gielly 1928, p. 52; Hautecoeur 1948, p. 11; Brulhart 1978, n.p. (as Abraham Beerstraten)
Exhibitions: Basel 1987, cat. no. 6

Two prominent trees with their network of bare branches dominate the foreground of this composition. A sharply foreshortened canal, populated by a horsedrawn sleigh and numerous skaters, fades into the far distance on the left, while behind the trees we see buildings of the village bordering the canal. The trees are almost a hallmark of the art-ist – neither Jan nor Abraham Beerstraten used trees with the same repoussoir function. The composition is closely related to earlier winter landscapes in the mode of Pieter Bruegel the Elder.[1] The picture's linear crispness of forms and the pale colors, made luminous by the rosy glow of an evening sky, recall similar compositions by Anthonie, for instance the so-called *Castle of Poelgeest*, a Leiden landmark (Bernt 1969, fig. 65) and the *Winter Landscape with Moated Castle* (ibid., fig. 66). The church in the present painting has been identified as *Onze Lieve Vrouwkerk*, a small Gothic church in Leiden that no longer exists.[2] As is often the case with Beerstraten, he has taken a prominent building out of its context and used it in an imaginary setting. A date in the early 1660s has been plausibly suggested for the composition.

1. Compare the *Winter Landscape with Bird Trap* by Pieter Bruegel the Younger, in the Dr. E. Delporte Collection, Brussels, which is a smaller copy after the painting by Pieter Bruegel the Elder (illustrated in *Apollo*, vol. 86, Dec. 1967, fig. 9).

2. See Basel 1987, p. 66.

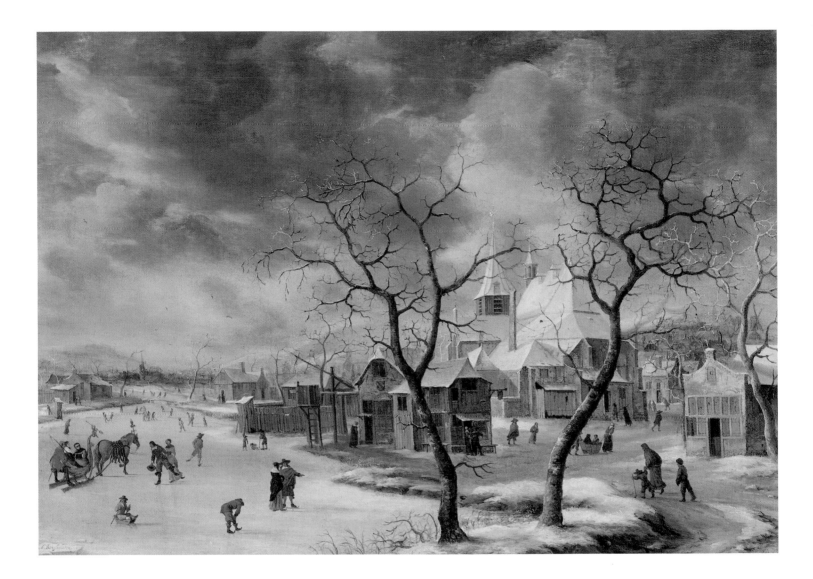

NICOLAES BERCHEM

Dutch, 1620–1683

*B*orn in Haarlem, Nicolaes Berchem first trained with his father, the still-life painter Pieter Claesz (q.v.). Houbraken mentions a few other artists as his teachers, Jan van Goyen, Nicolaes Moyaert, Pieter de Grebber, Johannes Wils, and Jan Baptist Weenix. The last named was his cousin, a year his junior, and they were probably collaborators rather than pupil and teacher. Berchem became a member of the Haarlem Guild of St. Luke in 1642. In 1650 he travelled with his friend Jacob van Ruisdael (q.v.) to Lower Saxony and Westphalia where they both made landscape sketches. Although a trip is not documented, the artist must have spent some time in Italy, probably in the 1640s and/or in 1653/54. He became the most famous and prolific painter of Italianate landscapes in Holland. However, he also executed a number of excellent history paintings. In c. 1660 Berchem settled in Amsterdam where he spent the rest of his life.

5. The Prodigal Son

Signed lower left: *NBerchem*
Canvas, 106 × 97 cm
Geneva, Musée d'Art et d'Histoire, inv. no. 1826-17
Provenance: Auction O.Z.H. Logement, Amsterdam, 1722; Collection D. van Diemen, Amsterdam, 1758; Auction G. Braamcamp, Amsterdam, 31 Juli 1771, no. 16; Auction Marquis de Changrand, Paris, 21/24 February 1780 (?); Auction de Sainte Foy, Paris, 22 April 1782, no. 31; Collection L.A. Brun, Versoix; Collection Jacob Duval, Geneva; Collection Favre-Bertrand, Geneva; Geneva, Musée Rath, 1826.
Literature: Hofstede de Groot, vol. 9 (1926), no. 25; Gielly 1928, p. 52; Von Sick 1930, pp. 25–26; Deonna 1943, no. 2; Hautecoeur 1948, p. 11; Pigler 1956, vol. 1, p. 51; Bille 1961, vol. 1, p. 72, vol. 2, pp. 4, 89, no. 16; Brulhart 1978, n.p.
Exhibitions: Basel 1987, no. 12

The Prodigal Son (Luke 15:11–32) is one of the most popular parables represented in the visual arts from the thirteenth century onwards. Berchem's painting portrays the scene of "The Prodigal Son Feasting with Harlots." This theme gave painters an opportunity to show their skill in rendering rich clothes and ornaments worn by seductive women, as well as sumptuous still lifes of luxurious foods and wine in glittering vessels, all the frivolities on which the Prodigal Son wasted his father's portion.

Dutch seventeenth-century painters traditionally set this scene in the interior of an inn, but Berchem created a classical temple setting in the Venetian style, with a statue of Venus presiding on a high pedestal on the left. A flaming heart held by Venus and two chained apes placed near her are symbols of lust.[1] The elegant figures of the Prodigal Son and his courtesan, framed by the classical portico behind, dominate the circle of revellers around them. The architectural features seem to have been derived from prints after Paolo Veronese which were popular in seventeenth-century Holland. The finely drawn figures, harmonious colors, and classically balanced composition make this one of the most accomplished history paintings by Berchem. Although the iconography is unusual, the title of the picture goes back to the earliest records. The painting is a pendant to cat. no. 6, discussed below.

1. Basel 1987, p. 76.

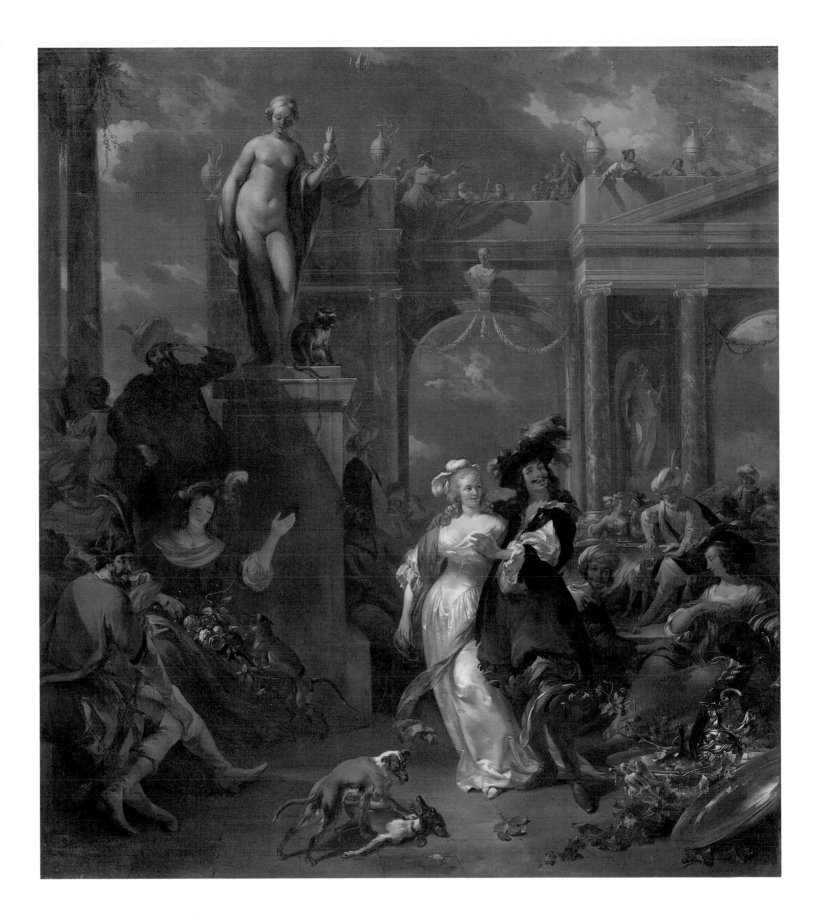

NICOLAES BERCHEM

6. Abraham Regains Sarah from King Abimelech

Signed lower left: *NBerchem f*
Canvas, 105 × 98 cm
Geneva, Musée d'Art et d'Histoire, inv. no. 1826–18
Pendant to no. 5 above
Provenance: Identical with cat. no. 5 above
Literature: Hofstede de Groot, vol. 9 (1926), no. 3; Gielly 1928, p. 52;
Von Sick 1930, pp. 25–26; Deonna 1943, p. 2; Hautecoeur 1948, p. 11;
Pigler 1956, vol. 1, p. 46; Bille 1961, vol. 1, p. 72, vol. 2, pp. 4–4a, 89,
no. 16; Brulhart, n.p.
Exhibitions: Basel 1987, no. 11

The story from Genesis (chap. 20) relates how Abraham travelled to the Kingdom of Gerar, pretending that his wife, Sarah, was his sister. Abimelech, King of Gerar, hearing of Sarah's beauty, had her brought to his court to make her one of his concubines. That night God appeared to the king in a dream, revealing Sarah's married status and threatening death to the king and his people unless she was returned to her husband. Abimelech, frightened by his dream and horrified at his unintended attempt at adultery, took Sarah back to Abraham and showered him with gifts in an attempt at reconciliation.

The painting shows Abraham kneeling on the left with both hands outstretched towards Sarah, who approaches from the right accompanied by a Moor and a richly dressed oriental dignitary. King Abimelech, scepter in hand, watches from a raised position in the center. For the setting of this scene, Berchem drew on the full repertoire of classicizing Italianate landscape. A richly carved classical urn placed left of center dominates the composition. The background shows a palace on the left, behind the king's retinue, and formal gardens on the right. The warm glow of an evening sky permeates the scene. The composition recalls the Italianate landscapes by Jan Baptist Weenix.

The Old Testament episode of Sarah's return to Abraham is rarely featured in the visual arts. Berchem's choice of the subject for a painting apparently intended as a pendant to the *Prodigal Son* (cat. no. 5) has been explained as an attempt at juxtaposing representations of honest married love with sinful lust.[1] However, there are many more conventional themes of married love which Berchem could have chosen. The subject of this painting must have been stipulated by a patron for reasons now obscure.

This painting and the *Prodigal Son* belonged in the eighteenth century to the famous collection of G. Braamcamp in Amsterdam. Stylistically both works are related to a distinguished group of Mediterranean port scenes that Berchem executed in the 1660s.[2] One of these works, in the Wadsworth Atheneum, Hartford (Sumner Collection 1961.29), was previously owned by Jan Six, who interpreted it as another scene in the Sarah and Abimelech episode[3]. However, the female figure in the Hartford painting does not resemble the Sarah in cat. no. 6; she is more akin to the concubine in the *Prodigal Son*. This elegantly dressed female figure reappears in most of the port scenes, often accompanied by a dandy who resembles the figure of the Prodigal. The raised figure of Venus is also present in these paintings.

Haverkamp-Begemann rejected Jan Six's interpretation, calling the Wadsworth Atheneum picture *A Moor Presenting a Parrot to a Lady* and suggesting that it probably reflects a seventeenth-century Dutch interpretation of life and leisure in the Mediterranean.[4] However, the iconography of these closely linked scenes seems open to further research.

1. Basel 1987, p. 76.
2. Related paintings are in Dresden (Gemäldegalerie), London (Wallace Collection), Rouen (Musée des Beaux Arts), and Hartford, CO. (Wadsworth Atheneum).

3. Six 1919, p. 83.
4. Haverkamp-Begemann 1978, p. 116, cat. no. 13.

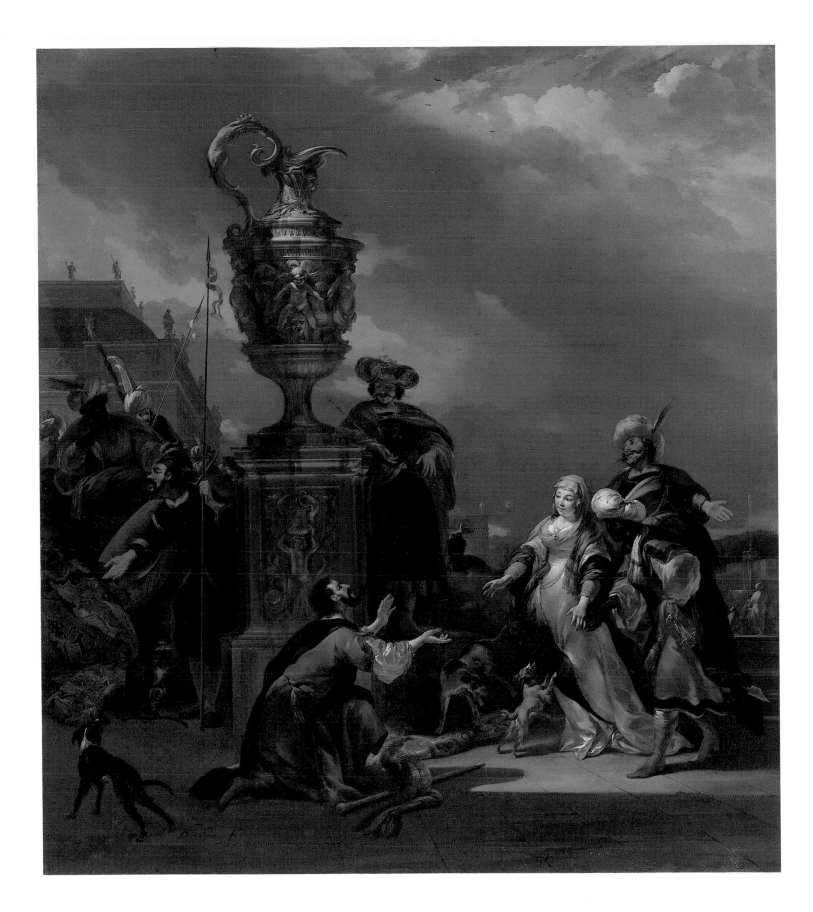

JAN BOTH

Dutch, c. 1615–1652

*B*orn in Utrecht, Jan Both trained with his father, the glass painter Dirck Both, and possibly with Abraham Bloemaert. A stay *in Rome with his brother Andries (1612–1642), from c. 1638 to 1642, proved crucial to Jan's development. The influence of Claude Lorrain, with whom he collaborated in 1639, is clearly evident in Jan's paintings. His landscapes are imbued with Claude's golden light and reflect the French artist's early views of the Campagna, done in the 1630s. However, Both's scenery is more accurately observed from nature than are Claude's idealized compositions. Most of Both's landscape paintings date from the years he spent in Utrecht after his return from Italy, from 1642 until his premature death. His profound influence on Dutch seventeenth-century landscape painting was not confined to the painters of the Italianate school but played a decisive part in the development of one of Holland's greatest landscape artists, Aelbert Cuyp.*

7. *Italian Landscape*

Signed on a rock, lower center: *JBoth* (JB in ligature)
Canvas, 44 × 66 cm
Jakob Briner Foundation, Winterthur
Provenance: Auction J. Danser Nijman, Amsterdam, 16 August 1796, no. 3; Christie's, London (Crawford Collection), 26 April 1806, no. 15; Auction William Wells, Redleaf, London, 12 May 1849; Auction Ch. Scarisbrick, London, 10 May 1861; Friedrich Rappe, Stockholm; Auction Bukowski's, Zurich, 2 June 1983, no. 9; acquired at auction
Literature: Smith 1835, vol. 6, no. 20; Granberg 1911, vol. 1, p. 73, no. 327, and vol. 2, fig. 69; Hofstede de Groot, vol. 9 (1926), no. 124; Burke 1976, p. 246, no. 110, fig. 96; Wegmann 1986, pp. 2,3
Exhibitions: British Institution 1824, no. 48

Like most of Both's landscapes, this luminous vista of hills, woods, and a lake is composed from elements the artist observed and sketched in the Roman Campagna. The picture clearly shows the influence of early works by Claude Lorrain done in the 1630s when Both was in Rome. Stechow juxtaposed Claude's landscape now at Boston entitled *The Mill* (1631 or 1637) with Both's painting of a Campagna scene of c. 1645 in Indianapolis to demonstrate this influence.[1] The Briner landscape, which dates from the same period as the Indianapolis painting,[2] is compositionally even closer to Claude's *The Mill*. Both paintings feature a lake in the middle distance flanked by trees, some of whose bare branches make a pattern in the sky. In each work, a strip of land with figures occupies the foreground while a range of distant hills, bathed in golden light, closes the composition. In comparison to Claude's painting, however, Both has reduced the scale and importance of figures and architecture and has filled his composition with rich foliage and vegetation to create an evocative study of nature.

1. Stechow 1966, pp. 154–55, figs. 299, 300. Stechow makes it clear that Both's landscapes show no relationship to Claude's later, more classical compositions, but that they are inspired by Claude's early landscape style.

2. Burke dates the Briner painting to c. 1645, and the Indianapolis painting (Burke, no. 41) to 1645–50.

Quirijn van Brekelenkam

Dutch, c. 1620–1668

Probably born in Zwammerdam, near Leiden, in 1648, Quirijn von Brekelenkam is recorded in Leiden as one of the founder-members of the Guild of St. Luke. Brekelenkam specialized in the painting of genre scenes, usually featuring interiors of households, workshops, or kitchens. His style owes something to the great Leiden genre painters Gabriel Metsu and Gerrit Dou. Like so many Dutch seventeenth-century artists, he had to supplement his income, and he held a license to sell wine and spirits. He lived and died in Leiden, where he raised a large family.

8. A Peasant Kitchen

Signed and dated lower left: *Q.B.1659*
Panel, 56.5 × 74.5 cm
Geneva, Musée d'Art et d'Histoire, inv. no. CR 23
Provenance: Collection Eynard, Geneva (?); G. Revilliod, Geneva; legacy G. Revilliod, 1890
Literature: Gielly 1928, p. 20; Hautecoeur 1948, p. 14; Brulhart 1978, n.p.; Lasius 1987, no. 138
Exhibitions: Basel 1987, no. 27

The scene is painted in the artist's characteristic palette of warm brown and rust tones with the meticulous brushwork of the Leiden school. The subject of the peasant kitchen harks back to a long tradition of Flemish genre painting and graphics, often with allegorical connotations.[1] The boy blowing bubbles in this scene is a traditional symbol of the transitoriness of human life, and the figure of the maid scrubbing a pot may allude to the futility of human endeavor.[2]

The construction of the interior space recalls Gerrit Dou and is similar to a few other paintings by Brekelenkam, particulary the *Woolspinner and his Wife* in the Philadelphia Museum of Art (Lasius, no. 59).

1. See for instance *The Rich Kitchen* and *The Poor Kitchen*, engravings after Pieter Bruegel the Elder, 1563 (Bastelaer 159 and 154).

2. An emblem by Jacob Cats has been suggested as a possible source for the figure of the maid (see Basel 1987, p. 106).

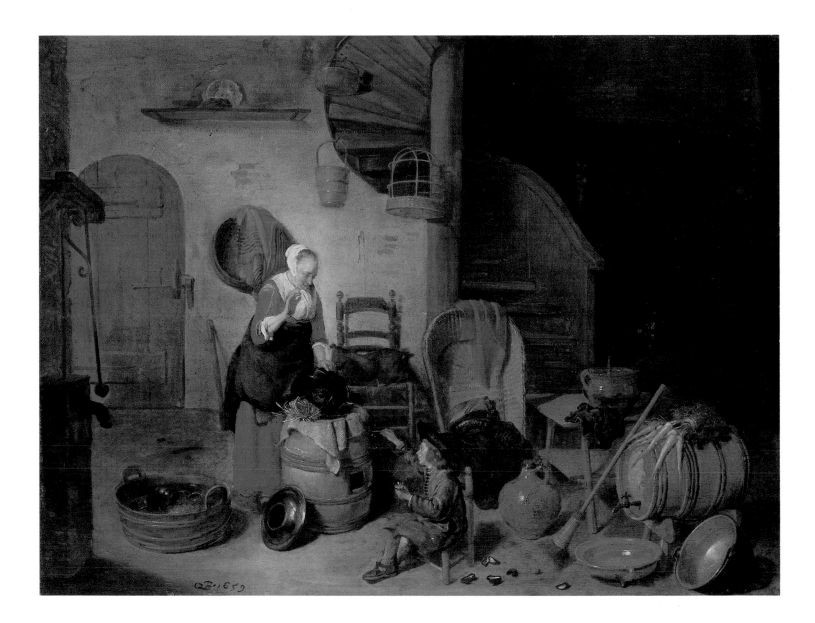

ELIAS VAN DEN BROECK

Dutch, c. 1650–1708

Elias van den Broeck was probably born in Amsterdam where he was later a pupil of the flower and fruit painter Cornelis Kick. In 1673 he became a master of the St. Luke's Guild in Antwerp. He specialized in painting flowers, fruit, and insects. His style was influenced by Jan Davidsz de Heem, whose work he must have seen in Antwerp. His compositions follow the example of Willem van Aelst. From 1685 he worked in Amsterdam, where he died. Van den Broeck's best work approaches the quality of still lifes by Rachel Ruysch (q.v.).

9. Still Life of Flowers and Fruit

Signed lower right: *Elias vDen Broeck*
Canvas, 70 × 58 cm
Geneva, Musée d'Art et d'Histoire, inv. no. CR 25
Provenance: Collection G. Revilliod; legacy G. Revilliod, 1890
Literature: Gielly 1937, p. 20; Brulhart 1978, n.p.

The rich still life of flowers and fruit, partly resting on a stone table top and partly cascading from a stone urn, is composed in an asymmetrical arrangement that the artist derived from Willem van Aelst. The composition resembles Van den Broeck's *Nosegay* in the Copenhagen Museum of Fine Arts,[1] where, however, the fruit is omitted. The large leaves with their carefully traced prominent veins are a characteristic feature of Van den Broeck's still lifes.[2]

1. See Bernt 1969, vol. 1, no. 194.

2. Bol 1969, pp. 294, 298, figs. 267, 307.

JAN BRUEGHEL THE ELDER
Flemish, 1568–1625

J an Brueghel the Elder was born in Brussels, the second son of Pieter Bruegel the Elder, but spent most of his life in Antwerp. In 1590, Jan travelled to Italy, and from 1592 he stayed in Rome where he was greatly influenced by Paul Bril. In 1595 he moved with his patron, Cardinal Federigo Borromeo (who became archbishop of Milan), to Milan, and in 1596 he returned to Antwerp where he became dean of the Guild of St. Luke. He worked for the archdukes Ferdinand and Isabella and also became a close friend and collaborator of Rubens, for whom he painted landscape backgrounds, animals, and flowers. His colorful landscapes are often on a very small scale; they feature wooded scenes, hills, and villages, sometimes including water and shipping. Jan also specialized in still life and flower painting. His exquisite colors and velvet-smooth finish earned him the nickname "Velvet" Brueghel.

10. *The Sacrifice of Isaac*

Panel (tondo), 21 cm diameter
Geneva, Musée d'Art et d'Histoire, inv. no. 1910–149
Provenance: Collection Toepffer; Toepffer bequest 1910
Literature: Ertz 1979, cat. no. 71, p. 210, fig. 256

The figures of Abraham and his son, Isaac, are set on a densely wooded hill that overlooks a mountainous landscape receding into the far distance. This compositional scheme, which omits the middle distance, is characteristic of Brueghel's landscapes from the early part of his career. A number of Northern artists conceived their landscapes in this way, among them Lucas van Valckenborch, Hans Bol, and Gillis van Coninxloo, but none painted with Brueghel's refinement and sensitivity. Ultimately this type

of landscape composition is derived from Jan's father, Pieter Bruegel the Elder. The closely set trees with their entangled foliage are reminiscent of Coninxloo's forests.

While Italian Renaissance painters, when depicting Abraham's sacrifice of Isaac, usually focused on the dramatic physical interference by the angel as he arrests Abraham's raised arm at the moment Abraham is about to slay his son, Brueghel's angel is still far away, approaching from the sky. The disposition of the tiny figures and the structure of the landscape follow the example of Hans Bol's drawing in the Uffizi, dated 1573, of the same subject.[1]

The tondo format, which Jan Brueghel used on several occasions, was popular with late sixteenth and early seventeenth-century Netherlandish painters for landscape compositions with a mythological, religious, or allegorical context.

1. See Franz 1969, vol. 2, fig. 313.

PIETER CLAESZ

Dutch, 1597/8–1661

Pieter Claesz was born in Burgsteinfurt, Westphalia, but worked most of his life in Haarlem. With Willem Claesz Heda he was the most famous exponent of the monochrome breakfast piece ("monochrome banketje") in Haarlem. Although his works are sometimes confused with Heda's, his brushwork is broader and his palette retains a warm brown tonality. He was probably influenced by Frans Hals and inspired by the "breakfast pieces" in the latter's famous banquet scenes of Haarlem officers. Claesz was the father of the painter Nicolaes Berchem (q.v.).

11. Still Life with Overturned Gilt Cup

Signed in monogram and dated: *PC 1637* (PC in ligature)
Panel, 66.5 × 92 cm
Jakob Briner Foundation, Winterthur
Provenance: Johannes Stumpf, Berlin; Auction Rudolph Lepke, Berlin, 7 May 1918, no. 72; Auction Spik, Berlin, 6 July 1973; C. Bednarczyk, Vienna; purchased 1983
Literature: Zimmermann 1908, pp. 51–52, fig. XXIII; *Der Cicerone* 1918, pp. 108, 109, ill.; Vroom 1980, vol. 1, p. 186, vol. 2, p. 87, no. 426 (as Adriaen Kraen); Wegmann 1986, pp. 4–6

Stylistically and in the choice and presentation of its objects, this still life is a characteristic production of the artist's middle period. Resting upon the white tablecloth are various items associated with the typical Dutch breakfast piece. In addition to the food on simple pewter plates there are two precious vessels, both tumbled over; they represent a variation on the *vanitas* theme that permeates Dutch seventeenth-century still life painting. Together with the partly eaten pie, bread, and nuts, with their debris, and together with pepper, a costly luxury spilling over from a paper cornet, they emphasize the impermanence and precariousness of human pleasures. However, the objects in Claesz's painting may also have religious symbolism: the cross-shaped frame of a window is reflected three times in the Roemer glass, which is half filled with wine. Bread and wine were often used as symbols of the Eucharist, and the reflection of the cross in the glass reinforces this connotation.[1] Pieter Claesz, like other Dutch seventeenth-century still-life painters, was a master of subtle, often ambivalent allusion, expressed in exquisitely rendered arrangements of realistically observed domestic objects.

1. See Anne Lowenthal, "Response to Peter Hecht", in *Simiolus,* vol. 16 (1986), no. 2/3, pp. 188–90. Anne Lowenthal is currently preparing a study of Peter Claesz to be published as a book.

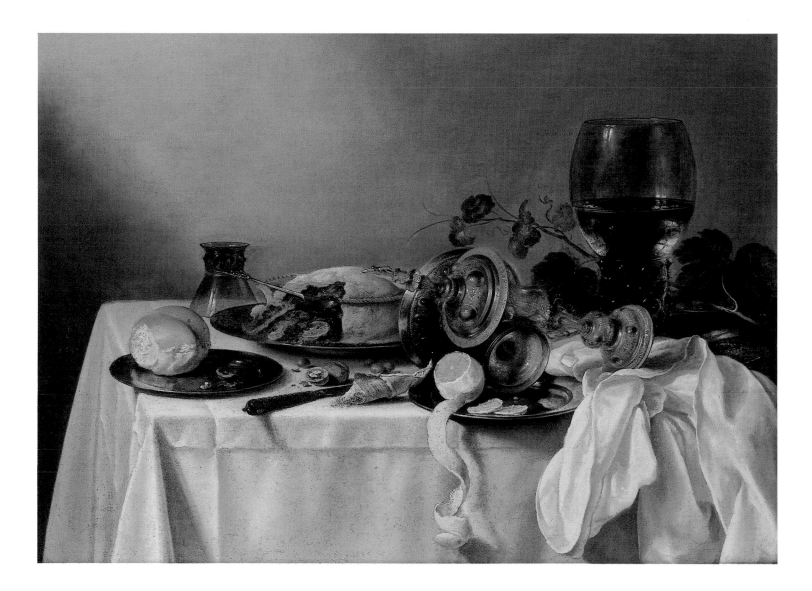

PIETER CODDE

Dutch, 1599–1678

*S*on *of a minor government official, Pieter Codde spent all his life in Amsterdam. He is mainly known as a genre painter who specialized in depicting elegant dancing and musical parties and barrack scenes. But he also produced portraits and, in 1637, completed a civic-guards group portrait left unfinished by Frans Hals (Rijksmuseum, Amsterdam, inv. C374). He painted in a distinctive palette of sombre greys and blacks, enlivened by brilliant highlights.*

12. A Musical Party

Signed and dated on the sheet of music: *PC 1632*
Panel, 30.5 × 37 cm
Jakob Briner Foundation, Winterthur
Provenance: Auction Fr. Muller, Amsterdam, 17 April 1956, cat. no. 1422
Literature: Wegmann (forthcoming)

The theme of the musical company emerged from allegorical representations, such as the Five Senses, in which music illustrated the sense of hearing. By Pieter Codde's time, the subject had become autonomous; nevertheless, musical instruments, such as the lute and the viola on the right, often symbolized vices or virtues ranging from illicit love to marital harmony.[1]

The mood of this painting is ambiguous: the seated couple are serenely engaged in singing or reading music, while the poses and expressions of the standing pair suggest that the lady is half-heartedly rejecting the young man's advances. The musical instruments and sword left unattended on the right before the curtained bed point at an amorous context (it must be remembered, however, that beds were standard furnishings in every Dutch living room).

Pieter Codde had literary aspirations and occasionally wrote poetry. He associated with playwrights.[2] In this painting, he may have intended to illustrate a specific text from a song, poem, or play. The artist repeatedly painted variations of the musical company theme in the late 1620s and 1630s.

1. Amsterdam 1976, pp. 105–107.

2. Philadelphia/Berlin/London 1984, p. 174.

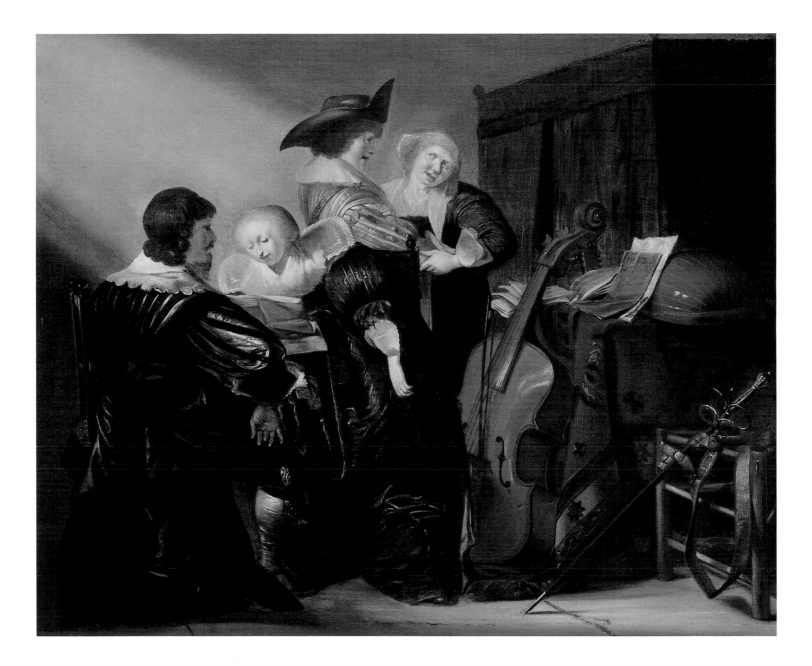

WILLEM HERMANSZ VAN DIEST

Dutch, 1610–after 1663

Willem van Diest lived in The Hague where he is documented in the records of the St. Luke's Guild of 1639 as a "scheepschilder" (marine painter). Contemporary marine painters in The Hague were Jan van Goyen (q.v.), Abraham van Beyeren, and, c. 1630, Jan Porcellis. In the 1630s and 1640s, Van Diest shared the silver-grey tonality of these painters of monochrome seascapes. From c. 1650 he also painted calm seas in a more colorful palette. In 1656 he was a founder member of the confraternity Pictura, set up by practitioners of the "Fine Arts" in emancipation from the craft-oriented St. Luke's Guild. Willem's son Jeronimus van Diest continued the marine-painting tradition of his father.

13. Shipping in a Calm

Signed and dated lower right: *W.V. DIEST 1649*
Panel, 51 × 72 cm
Jakob Briner Foundation, Winterthur
Provenance: Collection Beriah Botfield (d. 1863), Norton Hall, Northamptonshire; Marquis of Bath, Longleat House; David Koetser Gallery, Zurich; Bruno Meissner, Zurich; purchased 1987
Literature: Catalogue of Pictures at Norton Hall, London, 1863

This sunny calm seascape is an early example of the type that supplanted the grey/brown choppy seas the artist painted during his preceding monochrome phase. The present picture suggests the influence of Simon de Vlieger who, with Jan van de Cappelle, developed a new type of marine painting, featuring vast cloud-filled skies, a very low horizon, and a few vessels whose hulls and sails are mirrored in the nearly smooth water. A row of fish-nets and fishermen coming to collect the fish mark the picture's first plane. The long narrow strip of shadowed beach on the right is a traditional repoussoir device introduced c. 1600 by the first Dutch marine painter, Hendrick Vroom.

Van Diest's ships are not as accurately drawn as those of De Vlieger and other leading Dutch marine painters, and he has not fully understood how to paint ships in correct perspective.[1] However, the composition, with its low horizon and emphasis on an unlimited flow of space is fully representative of the new view of nature developed by Dutch marine and landscape painters of the period. The picture has much in common with Van Diest's *Calm Sea*, dated two years later (1651), in the Kunsthistorische Museum, Vienna.[2]

1. Verbal information kindly offered by Michael Robinson who adds that the faults in ship construction here seen are fairly typical of Van Diest's manner.

2. Bol 1973, p. 165, fig. 168.

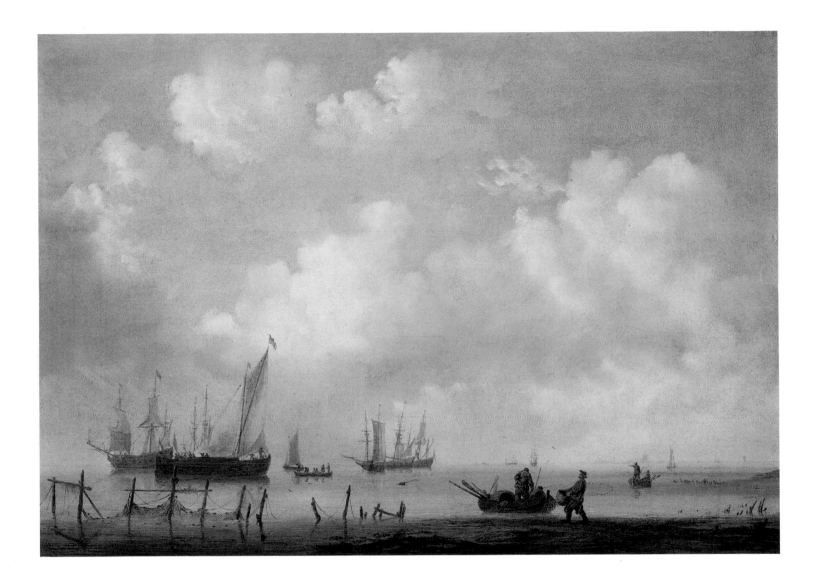

CAREL DUJARDIN

Dutch, 1621/22–1678

This artist's birthplace is not known, but he was active mainly in Amsterdam. Carel Dujardin studied with Nicolaes Berchem (q.v.) and, like his teacher, travelled to Italy, probably in the 1640s and again in 1675. Dujardin became one of the best known painters of Italianate landscapes and of Roman street scenes, called "bambocciate". His less numerous history paintings are probably late works, dating from after 1660. He died in Venice on his second trip to Italy.

14. Christ on the Cross with the Virgin, the Magdalen, and St. John the Evangelist

Signed lower left: *K. DU IARDIN Fe*
Canvas, 115 × 73 cm
Geneva, Musée d'Art et d'Histoire, inv. no. 1860-1
Provenance: Lyon, Cathedral of S. Jean; Collection Moutonnat, Geneva; Collection James Audeoud, Geneva, cat. 1848, no. 42; acquired from the heirs of J. Audeoud, 1860
Literature: Rigaud 1876, pp. 338–39; Hofstede de Groot, vol. 9 (1926), no. 21; Brochhagen 1958, pp. 65–66; Brulhart 1978, n.p.; Basel 1987, p. 44, ill., p. 45, fig. 8

According to Houbraken, Dujardin stayed in Lyon on his return from his first trip to Italy in the 1640s and he married a woman from that city. The style of this picture, however, points to a later date. It is plausible that the artist, because of his family connections, stopped again in Lyon on his second trip to Italy in 1674/75 and painted this altarpiece for the Cathedral of S. Jean at that time.

Christ is shown expiring on the cross, with the Magdalen embracing his feet and touching his wound with one finger. Her action refers to the earlier incident in the life of Christ when Mary Magdalen, the repentant sinner, anointed Christ's feet. The two seated figures bent in grief are the Virgin and St. John. The composition, with its moving simplicity, seems to be derived from Flemish rather than Dutch or Italian examples. The figure of Christ suggests that Dujardin must have known Van Dyck's *Crucifixion* in Antwerp or one of the many versions or copies of that painting.[1] The Magdalen, with her rich golden hair, is reminiscent of Rubens's depiction of her in the Antwerp *Descent from the Cross* or in the *Coup-de-Lance*.

1. Koninklijk Museum voor Schone Kunsten, Antwerp. There is a close version in the Kunsthistorische Museum, Vienna. Both paintings are illustrated in Klassiker der Kunst, 1909, *Van Dyck*, pp. 84, 85.

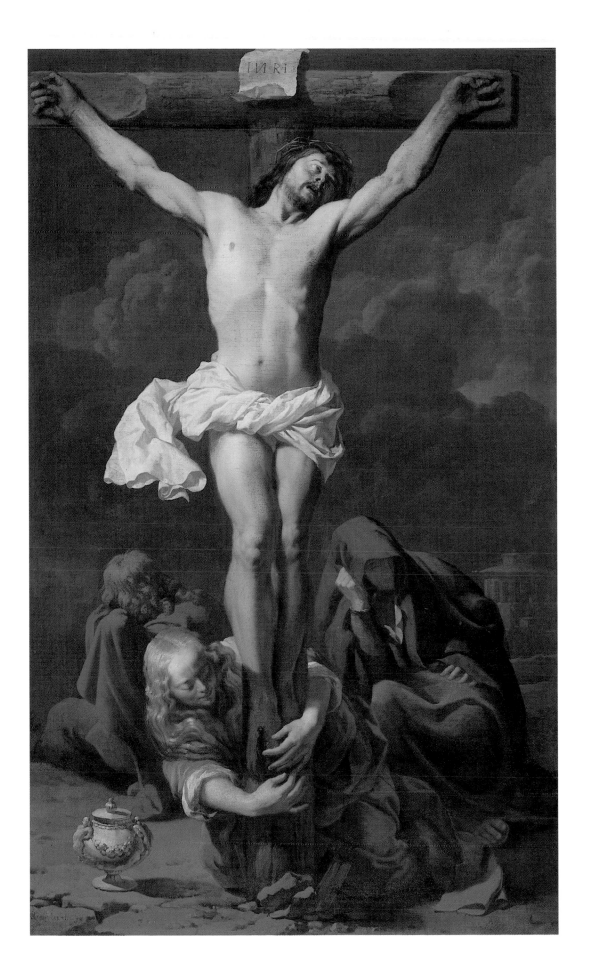

JAN VAN GOYEN

Dutch, 1596–1656

Having received his early training at Leiden, his birthplace, Jan van Goyen moved to Haarlem before 1618 where he became a pupil of Esaias van de Velde (q.v.), an artist who decisively influenced his development. From 1634, Van Goyen lived in The Hague where he became head of the Guild of St. Luke in 1638 and 1640. He travelled widely in Holland and part of Germany, making many drawings of topographical motifs. Together with Pieter de Molijn (q.v.), Salomon van Ruysdael, and Jan Porcellis, Van Goyen developed a new type of landscape and marine painting, the so-called tonal or monochrome manner. He was one of the most important and prolific Dutch seventeenth-century painters of landscape and marine subjects.

15. River View with a Round Bastion

Signed and dated on the base of the bastion: *vG1638*
Panel, 26.5 × 42 cm
Jakob Briner Foundation, Winterthur
Provenance: Art Dealer Prof. Singer, London, 1951; P. de Boer, Amsterdam, 1952; Auction Galerie Koller, Zurich, 21 June 1985, no. 5026; acquired at auction
Literature: Beck 1973, vol. 2, cat. no. 729; Wegmann 1986, pp. 9, 10

This painting is a characteristic example of Van Goyen's monochrome river scenes where local colors are absorbed in an overall neutral atmosphere. The river, with its distant sailboats, sweeps diagonally towards the low horizon on the right. The fortifications on the left are imaginary but reminiscent of the Valkhof at Nijmegen. Similar motifs are found in other of Van Goyen's paintings and in his drawings.[1] With its emphasis on the sky and the luminous reflections created by light filtering through the clouds, this painting anticipates the achievements of the marine painters of the Golden Age (see cat. nos. 13 and 42).

1. See Beck 1973, nos. 343–67

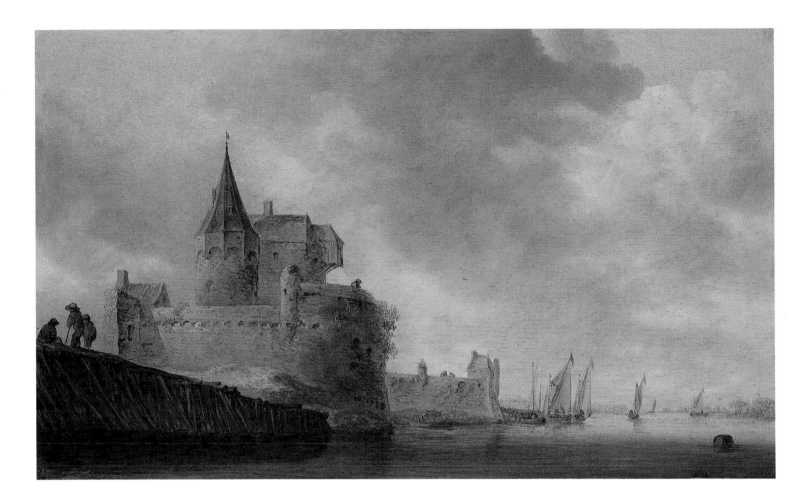

MEINDERT HOBBEMA

Dutch, 1638–1709

Meindert Hobbema was born and spent all his life in Amsterdam. His teacher during the second half of the 1650s was Jacob van Ruisdael (q.v.), whose influence is evident in Hobbema's wooded landscapes. The majority of Hobbema's paintings are dated between 1658 and 1668. After his marriage in 1668, when he took a job as a wine gauger, he seems to have painted less, but he still produced masterpieces, notably the "Avenue at Middelharnis," dated 1689, in the National Gallery, London. His landscapes, though clearly derived from Ruisdael, are sunny and serene in character and easily distinguished from Ruisdael's solemn grandeur.

16. Landscape with Broken Oak Tree

Canvas, 94 × 126 cm
Geneva, Musée d'Art et d'Histoire, inv. no. 1942–17
Provenance: Collection Jacob Duval, 1804; Collection Favre-Bertrand; Collection Guillaume Favre, Geneva; legacy Guillaume Favre, 1942
Literature: Rigaud 1876, p. 334; Mandach 1905, p. 2, fig. 4; Hofstede de Groot, vol. 4 (1911), p. 424, no. 153; Broulhiet 1938, vol. 1, p. 419, vol. 2, p. 258, no. 313; Deonna 1943, p. 170, no. 13; Brulhart 1978, n.p.
Exhibitions: Geneva 1850, no. 26; Bern 1943, no. 6; Neuchâtel 1953; The Hague/London 1971, no. 70; Basel 1987, no. 43.

The eye is easily led into this pleasant landscape by a sandy path that runs alongside a shallow brook and past trees and a red brick building towards a sunny clearing in the middle distance. The drifting cumulus clouds cast their shadows over the ground in a manner comparable to Jacob van Ruisdael's masterly effects of light and shade. The dead broken tree on the right is also reminiscent of similar dead trees found in Ruisdael's landscapes that were meant to indicate the passage of time and the transitoriness of life. While such symbolism may still be present in Hobbema's landscape, the mood is not as somber as that found in works by his master. The dead tree does not seem ominous; rather it works as an effective visual counterpoint to the lush foliage behind it. A few peacefully strolling figures animate the scene and emphasize its easy accessibility.

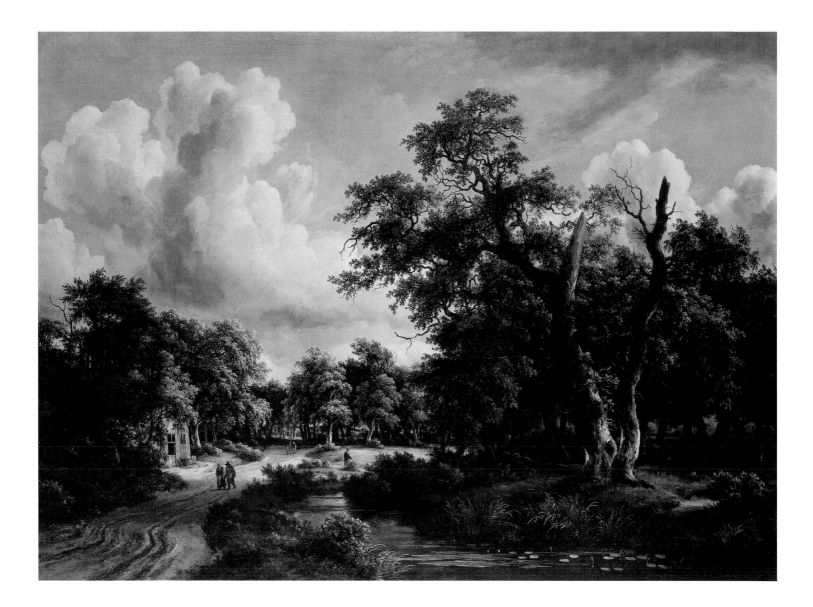

PIETER DE HOOCH

Dutch, 1629–1684

Born in Rotterdam, Pieter de Hooch trained with Nicolaes Berchem (q.v.). From 1652, he is recorded in Delft where he joined the Guild of St. Luke in 1655. Around 1661, De Hooch settled in Amsterdam where he remained for the rest of his life. His most famous works are the genre scenes of the Delft period, set in light-filled interiors or sunny courtyards. In Amsterdam, he painted fashionable people in elegant, often grand, interiors. The charm and spontaneity of the Delft pictures gave way to a more formal and somewhat rigid mode of representation. Like other Delft painters of the period, De Hooch was a great master at rendering light.

17. Lady Playing a Cittern

Signed upper left: *P.DHoogh*
Canvas, 67 × 57 cm
Kunstmuseum, Winterthur, inv. no. 1101
Provenance: Sale J. de Kommer, 15 April 1767, no. 20; Sale F. van de Velde, Amsterdam, 7 September 1774, no. 44; Sale S. van der Stel, Amsterdam, 25 September 1781, no. 66; Sale J.C. Werther, Amsterdam, 25 April 1792, no. 78; Sale A. Schuster et al., Cologne, 14 November 1892, no. 74; Collection Dr. Fritz Rieter-Wieland, Zürich; legacy Fritz Rieter-Wieland, 1970
Literature: Hofstede de Groot, vol. 1 (1907), nos . 143 and 168 (identical); Brière-Misme 1927, p. 277; Valentiner 1929, no. 167; Sutton 1980, cat. no. 139, pl. 142

A richly dressed young lady, prominently seated in the foreground, is playing a cittern.[1] She is accompanied by a flutist who is placed rather inconspicuously against the curtain on the left. The elegant figure of a gentlemen seen from the back appears in the middle distance. He is silhouetted against light streaming through a facing window. A girl seated near the window offers the gentleman a glass of wine. The window looks out on a brightly lit enclosed patio.

It is tempting to interpret this scene in terms of allegorical and symbolic meanings connected with the theme of music, but this painting clearly dates from the artist's late period in Amsterdam[2] when he was not concerned with moralizing but with representing the refined pursuits of a rich and leisured burgher class. These individuals valued music as a cultural accomplishment appropriate to their status.[3] The painting may well be a portrait in genre guise.

1. The cittern, or cither, not to be confused with zither, is an obsolete musical instrument resembling a lute. See Baines 1966, nos. 224–31. Information kindly supplied by Elisabeth Wells, curator at the Museum of Musical Instruments, Royal College of Music, London.

2. Sutton dates the picture to a very late period in the artist's career. See Sutton 1980, p. 114, no. 139.

3. Pieter Sutton rightly rejects implied symbolic or moralizing intentions in De Hooch's genre scenes, reminding us of the artist's obvious delight in representing the visual elements of the world for their own sake (see Sutton 1980, pp. 49–51).

JAN VAN KESSEL

Flemish, 1626–1679

B*orn in Antwerp, Jan van Kessel was the grandson on his mother's side of Jan Brueghel the Elder (q.v.) and a nephew of Jan Brueghel the Younger. In 1634/35 he was a pupil of Simon de Vos, but he seems to have collaborated also with his uncle, whose influence was much stronger. Van Kessel's small pictures of flowers, insects, and animals are inspired by Jan Brueghel the Elder, while some of his larger flower pieces follow the example of Jan Davidsz de Heem. Van Kessel's still lifes seem to have been collectors' pieces. They are frequently included amongst the pictures featured in paintings of Antwerp Kunstkabinets (art galleries).*

18. Still Life on a Terrace

Signed and dated lower left: *I.V.Kessel 1675*
Copper, 22.5 × 32.5 cm
Kunstmuseum, Winterthur, inv. no. 59
Provenance: From the Kunstkammer of the no-longer-extant Convent Rheinau; transferred to the Kunstverein Winterthur, 1864

From a terrace with classical columns a vista opens to the left towards formal gardens with a fountain and statuary. The facade of a palatial building appears in the background. The terrace platform in the first plane supports an abundant still life of fruit, vegetables, an orange tree in a tub, and a flowering plant in a stone pot. A Ming bowl on the right is filled with berries. The scene is animated with insects, butterflies, caterpillars, and two hamsters. Many of the still-life motifs are derived from the *Allegory of Earth* by Jan Brueghel the Elder in the Galleria Doria Pamphili, Rome, which was frequently copied by Jan Brueghel the Younger and his studio. The peacock on the base of a column has been copied in reverse from Jan Fyt's outdoors still life in Vienna.[1]

Still lifes in an outdoors setting, usually including birds, animals, or game, were popularized in Flanders by Jan Fyt, and in Holland by Jan Baptist Weenix and Melchior d'Hondecouter. Scenes like Jan van Kessel's still life combined a display of abundance in an aristocratic parkland ambiance with reminders of transitoriness. The insects and animals are gnawing on the fruit and plants, destroying their beauty.

1. Kunsthistorisches Museum, Vienna, no. 1171. See Greindl 1983, fig. 104.

THOMAS DE KEYSER
Dutch, 1596–1667

The son of a prominent architect, Hendrick de Keyser (1565–1621), Thomas de Keyser was born in Amsterdam. Before Rembrandt's arrival there in 1632, he and Nicolaes Elias were the most fashionable portrait painters in that city. Compared with Rembrandt's brilliance, De Keyser's style is rigid, but he had a good grasp of character and was capable of creating masterpieces, such as the portrait of "Constantin Huygens and his Secretary," 1627, in the National Gallery, London. From 1640, De Keyser was active as a stone mason and he was appointed as stone mason to the city of Amsterdam in 1662.

19. Portrait of a Man

Dated lower left: *AN°1634*[1]
Panel, 80 × 50 cm
Geneva, Musée d'Art et d'Histoire, inv. no. 1942–18
Provenance: Jacob Duval; G. Favre-Bertrand, 1820; bequeathed by the heirs of Favre-Bertrand to the Musée d'Art et d'Histoire, 1942
Literature: MS catalogue of the Collection Duval (as Van der Helst); Mandach 1905, p. 2, fig. 4; Oldenbourg 1911, p. 78, no. 59; Deonna 1943, p. 165, no. 2; Brulhart 1978, n.p.
Exhibitions: Geneva 1850, no. 25 (as Van der Helst); Berne 1943, no. 7; Neuchâtel 1953

The subject of this portrait, shown full length and characterized by his ample beard, is probably an Amsterdam burgher of some prominence. Dressed in embroidered black silk, he is holding a pair of gloves in his right hand while the left hand emerges from the folds of his cloak. The artist, while emphasizing the dignity of his subject, gave him a lively expression that was, no doubt, a good likeness. The man stands in a hall before a lofty stairwell. This complex architectural setting reflects the predilection of many Dutch mid-seventeenth-century painters for suggesting depth by linking together interior spaces. The formal pose of the subject suggests that this was an official portrait.

1. The artist's monogram, recorded in earlier catalogues, has disappeared, perhaps when the painting was cleaned in 1963.

CLAES MOLENAER

Dutch, c. 1630–1676

*C*laes Molenaer was a cousin of the well known genre painter Jan Miense Molenaer. Claes lived in Haarlem, where he joined the Guild of St. Luke in 1651. There he painted beach and river scenes and winter landscapes in the manner of Jacob van Ruisdael (q.v.) and Isaac van Ostade.

20. A Scene on the Ice Near a Town

Signed lower right: *Molenaer*
Panel, 37 × 34 cm
Jakob Briner Foundation, Winterthur
Provenance: Auction Lempertz, Cologne, 21 November 1957, no. 99
Literature: Wegmann (forthcoming)

Beside the buildings and ramparts of a town, a frozen canal supporting skating figures recedes diagonally into the distance. The compositional scheme, including a group of horses being fed near a building, is reminiscent of Nicolaes Berchem's *Ramparts in Winter Time,* 1647, in the Frans Hals Museum, Haarlem.[1] The heavy sky, which recalls Jacob van Ruisdael's somber winter landscapes, suggests the gloom of winter, rather than the joys of that season as seen in the bright, open-spaced skating scenes of Hendrick Avercamp (q.v.), Aert van der Neer, and many others. Molenaer, however, subtly lightens the mood with rosy tints in the evening sky that are reflected in the ice and on the thick walls of buildings. All forms are submerged in a rich atmospheric effect that skillfully unites the various motifs of the composition.

1. Illustrated in Stechow 1966, fig. 179.

PIETER DE MOLIJN

Dutch, 1595–1661

Born in London to Flemish parents, Pieter de Molijn joined the Guild of St. Luke in Haarlem in 1616 and lived in that city until his death. He was a landscape painter specializing in views of the dunes, but also painted forest and winter scenes. Together with Jan van Goyen (q.v.) and Salomon van Ruysdael, he was a pioneer of the so-called "tonal phase" of Dutch landscape painting that flourished in Haarlem in the 1630s. In the 1620s De Molijn also painted genre scenes in outdoor settings. He was the teacher of Allart van Everdingen.

21. Winter Scene

Signed lower center: *PMolyn*
Copper, 16 × 22.8 cm
Geneva, Musée d'Art et d'Histoire, inv. no. CR 111
Provenance: Collection G. Revilliod; legacy G. Revilliod, 1890
Literature: Gielly 1937, p. 20; Brulhart 1978, n.p.; Allen 1987, pp. 75ff., 125ff.

This lively scene on a frozen river with figures skating, conversing, and gathering around a booth, is clearly influenced by Esaias van de Velde (q.v.), who seems to have inspired De Molijn's landscape style in the 1620s. Winter landscapes, however, belong to De Molijn's later career, and the costumes in the present painting indicate a date after the early 1640s.[1] A skating scene with figures in similar costumes is signed and dated 1657.[2] The painting *A Skating Scene on the Merwede*,[3] also featuring a booth on the frozen river, is close to this composition. Other related works are the two slightly different versions of *A Frozen River with Skating and Sledging*.[4] These late works by De Molijn, as well as winter landscapes by Jan van Goyen, Aert van der Neer, Jan van de Cappelle, and Rembrandt van Rijn show the continued influence of Esaias van de Velde's winter scenes well into the mid-seventeenth century.[5]

1. Information kindly supplied by Avril Hart, Victoria and Albert Museum, London.
2. Sotheby's, London, 23 June 1982, no. 12.
3. Christie's, London, 14 April 1987, lot 102, and 4 May 1979, lot 63.
4. Christie's, London, /a/ 28 June 1974, no. 171, and /b/ 10 April 1981, lot 40.
5. Allen 1987, pp. 75ff., 125ff., dates this painting in the late 1620s.

PIETER DE MOLIJN

22. Stone Bridge across a River

Signed lower left: *P. Molijn*
Panel, 39.5 × 32.5 cm
Jakob Briner Foundation, Winterthur
Provenance: Auction Mak van Waay, Amsterdam, 19 January 1955, no. 77
Literature: Allen 1987, p. 207, ill. 303

Pieter de Molijn's vigorous early style, manifested in the panoramic dune landscapes, gave way to a certain amount of experimenting later in his career. In the 1650s he produced drawings with Italianate motifs and also a number of landscapes with an Italian flavor.[1]

A stone bridge is not an uncommon motif in works by earlier Dutch landscapists, such as Esaias van de Velde, but it is not treated as a prominent feature. The motif of the tall arched bridge occurs also in paintings by Jan Asselijn (q.v.),[2] Herman van Swanevelt, and Adam Pynacker[3] and other painters of the Italianate landscape during the 1650s. Another bridge structure similar to Molijn's, for example, appears in Nicolaes Berchem's *Italian Landscape with Bridge,* dated 1656, in the Hermitage, Leningrad.[4] Though attracted to foreign scenery in his late career,[5] Molijn did not attempt to emulate the golden light of Italianate painting. He preferred the subdued colors and neutral atmosphere of the monochrome phase of Dutch landscape painting.

1. Darmstadt, Hessisches Landesmuseum, no. 42, signed and dated 1653; and the Louvre, no. 22.756, signed and dated 1658, which features a temple resembling Tivoli. Another picture, in the Ecole des Beaux Arts, Paris (no. 393, signed and dated 1653), shows a ruined tower on a river, with plants growing from the stonework, in a treatment similar to the Briner river scene.
2. Steland-Stief 1980, cat. no. 148, pl. 29.
3. Blankert 1978, figs. 186a., 111.
4. Rosenberg/Slive/terKuile 1972, fig. 153B.
5. See Stechow 1966, fig. 269: *River Valley,* signed and dated 1659 (Berlin, Staatliche Museen), a painting characteristic of such late works. Hind proposed a trip to Switzerland and Italy by Molijn in 1658/59, because of the similarity of some drawings to Hackaert's Swiss scenes, but in the absence of any documentation Gerson discounts this theory (see Hind 1915–31, nos. 6, 17; Gerson 1942, p. 355).

EMANUEL MURANT

Dutch, 1622–1700

Born in Amsterdam, perhaps of Huguenot parentage, Emanuel Murant trained with Philips Wouverman (q.v.) and travelled extensively in France. He spent the last thirty years of his life in Friesland and died in Leeuwarden. Murant specialized in painting Dutch landscapes with villages and tumble-down farm buildings. His not very frequent paintings have certain affinities with those of Jan van der Heyden, particularly in their emphasis on carefully observed brickwork, but his style, though provincial, is highly personal and original, almost anticipating the flavor of French nineteenth-century landscapes of the Barbizon school.

23. Entrance to a Small Town with a Well

Remainder of a monogram, lower left: *E.M.*
Panel, 36.5 × 52 cm
Jakob Briner Foundation, Winterthur
Provenance: Auction Fred Muller, Amsterdam, 23 March 1955, no. 938

The rural scene (probably in Friesland) with farmers at their work outside the walls of a small town is dominated by the horizontal sweep of low buildings, with the spire of a church in the background. The meticulous way of rendering every brick with all its surface irregularities, causing infinitesimal fluctuations of light and shade, reminds us of Jan van der Heyden's skill in depicting masonry. Indeed, Houbraken praised Murant's amazing precision which enabled one "to count every brick in his walls," in much the same way he praised Van der Heyden's works. However, Murant's paintings are provincial in character, lacking the sophistication of Van der Heyden's meticulous portrayals of cities and town buildings. Other landscapes by Murant, such as the city view in the Museum of Copenhagen (no. 492) or the village scene in the Kunsthaus Zurich,[1] show the same patient attention to detail and convey the same feeling of rural tranquillity.

1. *Dutch Village near a Pond,* Stiftung Ruzicka, inv. R 19 (illustrated in Basel 1987, no. 61).

MICHIEL VAN MUSSCHER

Dutch, 1645–1705

Born in Rotterdam, Michiel van Musscher studied in Amsterdam with the portrait and history painter Abraham van den Tempel in the early 1660s. In 1665 he took lessons from the well known Amsterdam genre painter Gabriel Metsu, and in 1667 he worked three months with the Haarlem artist Adriaen van Ostade (q.v.). He painted genre scenes influenced by both these artists and produced a number of highly original portraits and self-portraits. From c. 1678 he lived in Amsterdam, where he died. In his later career, he became one of Amsterdam's most fashionable portrait painters.

24. Lady Playing a Viol da Gamba

Signed lower right: *M.V. Musscher P.,* dated upper left: *1677*
Canvas, 36 × 30 cm
Jakob Briner Foundation, Winterthur
Provenance: Christie's, London, 23 June 1950, no. 170
Literature: Wegmann (forthcoming)

The portrait shows a young lady, fashionably dressed in the style of the late seventeenth century and adorned with pearls, who is playing a bass viol. Despite the realistic appearance of this instrument, it does not seem to accurately represent a known model. [1] On the right, an open book of music rests on a table covered with the type of rich Persian rug that is to be found in most of Van Musscher's portraits. The painting exemplifies the artist's late style of portraiture. Its emphasis on elegant refinement appealed to his wealthy Amsterdam patrons. Young ladies of the period were frequently portrayed *en musicienne* to emphasize their social accomplishments. The inscription on the painting tells us the subject's age, eighteen, and the initials of her name, *A.v.W.*

1. The instrument resembles most closely a festoon-shaped bass viol (now called viol da gamba), as illustrated in Baines 1966, no. 97. See also David D. Boyden, *The Hill Collection,* London, 1969, no. 4. The artist paid little attention to a correct representation of the bass viol – the elongated body and exaggerated curvature of the instrument are decorative rather than exact. The addition of three silk bows emphasizes the decorative effect. Information kindly supplied by Elizabeth Wells, curator at the Museum of Musical Instruments, Royal College of Music, London.

PIETER NEEFFS THE ELDER

Flemish, active 1607–1656/61

A lifelong resident of Antwerp, Pieter Neeffs the Elder specialized in the painting of church interiors. In 1609 he was listed as a master in the Antwerp Guild of St. Luke. Neeffs followed the styles of Hendrick van Steenwijck the Elder and the Younger, sometimes copying their compositions. Other Antwerp artists, among them Frans Francken the Younger, David Teniers, and Sebastian Vrancx, painted the figures in Neeffs's churches. Pieter's son and pupil Pieter Neeffs the Younger continued his father's speciality in a very similar style.

25. Interior of Antwerp Cathedral

Signed on base of pillar on the right: *P. NEFS*
Panel, 39 × 49.5 cm
Jakob Briner Foundation, Winterthur
Provenance: Auction Fr. Muller, Amsterdam, 22 June 1954, no. 59
Literature: Wegmann (forthcoming)

One of the elder Pieter Neeffs's most popular compositions was this view of the interior of Antwerp Cathedral, of which he and his son painted many versions. The Briner version closely resembles the painting from a private collection exhibited in Edinburgh, 1984,[1] and another version in the Mauritshuis (no. 248). Both these versions are signed by Neeffs and by Frans Francken. Other close versions are in the Minneapolis and Budapest museums of art.

Like Steenwijck's *Interior of Antwerp Cathedral*, 1583,[2] these compositions are rooted in the tradition of perspective studies by Hans Vredeman de Vries. They show the length of the nave to the choir as seen from a high vantage point. In the present painting the perspective lines of the underdrawing, even the indentations from the compasses which were used to construct the ribs of the vault, are still clearly visible through the thin layers of paint.

Neeffs's views of Antwerp Cathedral, though not strictly accurate, are of particular interest because they show the interior after the installation of new altarpieces and monuments, in the early seventeenth century, to replace those destroyed in the iconoclastic riots of the sixteenth century. The sculptures of the Virgin and the Apostles, clearly visible on the columns of the nave, were placed there between the years 1610 and 1657.[3] The Briner painting probably originated at a time when these restorations were complete, or nearly complete, and is close to the version in Indianapolis, which is dated 1651.[4]

The sparse staffage is probably by Frans Franken the Younger. The figures were painted over the completed floor pattern and have become transparent.

1. Edinburgh 1984, cat. no. 9.
2. Jantzen 1910, p. 28, fig. 7.
3. Edinburgh 1984, cat. no. 9.

4. C. Lawrence, *Perceptions. An Annual of the Indianapolis Museum of Art*, vol. 2 (1982), pp. 17–21.

CASPAR NETSCHER

Dutch, c. 1639–1684

Caspar Netscher was the son of a German sculptor who worked in Heidelberg. Although the year and place of his birth are not known, he spent his childhood in Arnhem, where he trained with the still life, genre, and portrait painter Herman Coster. Around 1654 Netscher was a student of Gerard ter Borch in Deventer. After a stay in Italy and France from c. 1658, he joined the Guild of St. Luke in The Hague, where he settled for the rest of his life. From the 1670s Netscher was one of the most renowned portraitists in Holland, much in demand by court society and the rich bourgeoisie.

26. Portrait of a Lady (Maria Timmers?)

Signed and dated left: *C. Netscher. 1677*
Canvas, 47.5 × 38 cm
Jakob Briner Foundation, Winterthur
Provenance: Christie's, London, 16 June 1950, no. 93
Literature: Wegmann (forthcoming)

The young lady in this portrait is dressed in a sumptuous costume of silk and brocade inspired by the latest French fashions. By placing his sitter in a parkland setting Netscher followed a style introduced by Anthony Van Dyck earlier in the century. The suggestion that the sitter was the Duchess of Portsmouth, mistress of Charles II, must be rejected since portraits of the Duchess show a very different physiognomy. However the lady has a striking resemblance to Netscher's portrait of *Maria Timmers*, dated 1683, in the Mauritshuis.[1] The sitter's features, hairstyle, jewellery and pose – with the exception of the placement of the right hand – are virtually identical. It is also interesting to note that the measurements of the two canvases are identical. The Mauritshuis portrait was painted six years after the Briner portrait. If this is indeed Maria Timmers, it is possible that Netscher painted her again in the year of her marriage to Maurits le Leu de Wilhem, 1683, copying his earlier portrait but changing her gesture to point towards the portrait of her husband (painted by Netscher in 1667),[2] also now in the Mauritshuis.

1. Mauritshuis, The Hague, *Portrait of Maria Timmers (1657–1753),* wife of Maurits le Leu de Wilhem, married 1683. Signed and dated: *C. Netscher: fec 1683.*

2. Ibid. *Portrait of Maurits le Leu de Wilhem (1613–1724).* Signed and dated: *C. Netscher, 1667.*

Izaak van Oosten

Flemish, 1613–1661

The son of an art dealer, Izaak van Oosten was born and lived in Antwerp. He was a close follower of Jan Brueghel the Elder (q.v.); his small-scale landscapes with figures, often painted on copper, have sometimes been attributed to that more famous Antwerp artist. Van Oosten made free copies after works by Jan Brueghel but his own compositions are not without individuality. His brother Jan was also a landscape painter.

27. A Village Scene

Signed lower left: *I. v. Oosten fecit*
Panel, 30.5 × 43.5 cm
Jakob Briner Foundation, Winterthur
Provenance: Galerie Léger, Brussels; purchased 30 May 1936
Literature: Bernt 1969, vol. 2, no. 882; Wegmann (forthcoming)

One of Jan Brueghel's compositional schemes for his landscapes, from c. 1602, was a frontal view of a canal in deep foreshortening, with a village and staffage on one or both banks.[1] Van Oosten's picture is a free and simplified version of one of these scenes, the *Village Canal,* in a private collection.[2] Van Oosten retained the houses on both sides of the canal but reduced the number of trees to open up the view against the sky. Brueghel's tightly grouped elegant figures are replaced by a few farmers with cattle, a horse and wagon, poultry, and a dog. Boats are anchored in the center foreground, which is animated by a few figures, and a small boat is being rowed along the canal.

Van Oosten's rural genre scene is also reminiscent of some of Brueghel's paintings, such as the *Village Street* of 1605[3] and *Village Street with a Canal* of 1609.[4]

1. For examples see Ertz 1979, pp. 179–89.
2. Ertz 1979, cat. no. 85, fig. 28
3. Collection Knecht, Zurich, Ertz cat. no. 93.
4. Private collection, USA, Ertz cat. no. 196.

ADRIAEN VAN OSTADE

Dutch, 1610–1685

Adriaen van Ostade spent all his life, in his birthplace, Haarlem. According to Houbraken, he was a pupil of Frans Hals at the time when Adriaen Brouwer was also a pupil. In 1634 he became a member of the Haarlem Guild of St. Luke, serving as hoofd-man (secretary) in 1647 and 1661, and as dean in 1662. Ostade is one of the best known painters and etchers of peasant genre scenes. His paintings were popular in his own time and much sought after by English collectors in the eighteenth and nineteenth centuries. His brother Isaack and the artists Cornelis Dusart, Cornelis Bega, Michiel van Musscher (q.v.), and, perhaps the most famous of Dutch genre painters, Jan Steen, were amongst his pupils.

28. Interior with Peasants

Signed lower center: *Avostade* (Avo in ligature)
Panel, 21.5 × 30.5 cm
Jakob Briner Foundation, Winterthur
Provenance: Auction Baron Heinrich von Mecklenburg, Vienna, 11–12 November 1872; Collection Felix Kuranda, Vienna; Sotheby's, London, 30 November 1983, no. 74; Galerie Sanct Lucas, Vienna, cat. 1984/85, no. 8; acquired 1985
Literature: Österreichische Kunsttopographie 1908, vol. 2, p. 320, no. 15; Wegmann 1986, pp. 11–12

Hofstede de Groot, in a handwritten note, described this picture as "echtes Frühbild" (typical early work) by A. van Ostade.[1] It is a good example of the low-life genre scenes the artist painted in the early 1630s when he was greatly influenced by Adriaen Brouwer.[2] Paintings such as Brouwer's *The Pancake Baker* in the Philadelphia Museum of Art (John G. Johnson Collection, no. 68) must have inspired this type of composition. The coarse squat figures with their uncouth demeanor continue the tradition of peasant genre by Pieter Bruegel the Elder and his followers.

In a derelict cottage a peasant is engaged in reeling while his wife is cleaning mussels, taken from a tub. A boy and a girl frolic behind the woman's back on the right, and on the left the figure of a third child, used as a repoussoir, is seen squatting in back view, obeying the course of nature. Such near-caricatures of peasant life, called "drolleries", were much in demand; they were considered witty ("geestig") and entertaining ("aerdich"), and normally they lack any moralizing or didactic intentions.[3] The marked *chiaroscuro* effects in Ostade's early works betray a knowledge of Rembrandt's style in the late 1620s.

1. Wegmann 1986, p. 11.
2. For illustrations of comparable early works see Schnackenburg 1981, figs. 1–13.

3. Basel 1986, p. 188, no. 68.

Bonaventura Peeters

Flemish, 1614–1652

Born in Antwerp, Bonaventura Peeters was the leading artist of a family of marine and landscape painters. He became a master of the Guild of St. Luke in 1634. The last ten years of his life were spent in Hoboken, near Antwerp, where he died. His early works suggest that he spent some time in Holland, painting river scenes influenced by Salomon van Ruysdael and Simon de Vlieger, and realistic views of coastal cities in the tradition of Hendrick Vroom. Later in his career he painted fanciful Mediterranean and oriental ports, but his most famous works are dramatic storms and shipwrecks at sea. These stormy seas show the influence of the pioneering Flemish marine painter Andries van Eertvelt, but their bravura and inventiveness far outshine the work of the older master. Bonaventura Peeters sometimes collaborated with other painters; for instance, he added the figures to the church interior by Pieter Neeffs the Elder (q.v.) in the National Gallery, London (no. 2206).

29. Shipwreck near a Rocky Coast

Signed with monogram and dated lower right: *B. P. 1645*
Panel, 60.5 × 94 cm
Jakob Briner Foundation, Winterthur
Provenance: Earl of Sunderland; Earl Spencer, Althorp, to 1982; Galerie Sanct Lucas, Vienna, cat. 1983/84, no. 9; acquired 1984
Literature: Garlick 1974–76, p. 64, no. 491; Wegmann 1986, pp. 13–14
Exhibitions: Manchester 1857, no. 1013; Dublin 1872, no. 79

The painting is one of the most dramatic renderings of ships in a stormy sea being wrecked against a rocky shore, a frequently depicted subject in seventeenth-century Netherlandish marine painting. Houbraken praised Bonaventura Peeters as the best painter of such subjects in his time. The composition depicts with heightened intensity the struggle of man against the elements. Mountainous waves, driven before storm clouds, break almost audibly against a steep rock. One ship in the left foreground has lost her mizzen and foremast and is sinking. A sailor is climbing up the main mast while others cling to planks, hoping to reach the rocks where some of the crew are climbing up to safety. The two ships in the background are running before the gale and appear to be saved. In strong contrast to the turmoil below, the high rock with its fortifications leads towards sunny fields and the bright vista of a city on the far right.

The dynamic scene is obviously not intended to be realistic but illustrates the traditional symbolism of the ship as human life and the sea as representing the world with its vicissitudes. The rock and the fair city beyond are symbols of salvation.[1] Peeters was fully familiar with such symbolic concepts. He was not only a painter but also a poet, and on the verso of a drawing of a ship in a storm he wrote a poem describing the ship's voyage as man's passage through life.[2]

The brilliant pictorial effects of the Peeters shipwreck scene, with sun rays filtering through the ragged storm clouds in dramatic chiaroscuro, terminating in a rainbow, suggest that the artist must have been influenced by Rubens's visionary landscapes such as the *Shipwreck of Aeneas* of c. 1620 (Berlin-Dahlem), rather than by any contemporary marine painters.

Similar paintings of ships in a storm by Bonaventura Peeters are in a number of museums, including Darmstadt, Greenwich, Dieppe, and Salzburg.

1. From the middle ages and earlier, the ship, the sea, and rocks had many symbolic and, from the sixteenth century, emblematic, meanings, often mutually contradictory. For some of the symbolisms see Russell 1983, pt. 1, chap. 4, pp. 62ff.

2. Antwerp, Musée Plantin-Moretus, *Sailing Ship in a Storm*, no. 432.

EGBERT VAN DER POEL

Dutch, 1621–1664

Born in Delft, Egbert van der Poel was a pupil of Cornelis Saftleven in Rotterdam, where he lived from 1655. He painted still lifes, peasant genre scenes, landscapes, and beach scenes with many figures. A well known group of paintings features moonlight scenes, apparently inspired by Aert van der Neer, and nocturnal conflagrations. Van der Poel must have witnessed the explosion of the gunpowder magazine in his native Delft in 1654. He painted a large number of works that depict the aftermath of that catastrophe.

30. Sea Shore by Moonlight

Signed lower right: *E vander Poel*
Panel, 28.5 × 34 cm
Jakob Briner Foundation, Winterthur
Provenance: Auction Palais des Beaux-Arts, Brussels, 14 October 1953, no. 377
Literature: Wegmann (forthcoming)

This painting is a characteristic example of Van der Poel's moonlit beaches. The village silhouette atop the dunes on the left, with the pointed church steeple, suggests the coast of Scheveningen. The light of the full moon behind drifting clouds adds a pale luminosity to the sandy shore, the boats' sails, and the group of fishermen busy at their tasks. Several versions of the painting are known, some of which are dated in the 1660s.[1] The present picture must have originated in the same period.

1. Bol 1973, p. 200, fig. 204; Christie's, London, 17 December 1982, no. 114 (signed and dated 1662).

CORNELIS VAN POELENBURGH

Dutch, c. 1594–1667

Cornelis van Poelenburgh was born in Utrecht where, according to Sandrart, he was a pupil of Abraham Bloemaert, the leading painter of that city. From 1617 to 1621 he was in Rome, where he belonged to the circle of Paul Bril and became one of the founders of the Dutch artists' association, the "schildersbent." From 1621 he spent some time in Florence working for the Duke of Tuscany, but by 1625 he had returned to Utrecht where, apart from a few trips to England, he remainded for the rest of his life. Poelenburgh was the first artist to introduce Italianate landscape to Holland. He had a large workshop with many pupils. His small-scale italianizing landscapes with biblical, mythological, or genre scenes were much admired and exercised a great influence on Dutch seventeenth-century artists.

31. The Adoration of the Kings

Signed lower right with monogram: C.P.
Copper, 36.5 × 30 cm
Geneva, Musée d'Art et d'Histoire, inv. no. 1954-2
Provenance: Basel, private collection; acquired 1954
Literature: Brulhart 1978, n.p.; Sluijter-Seijfert 1984, pp. 104–105, 231
Exhibitions: Basel 1987, no. 71

The Adoration of the Kings is a relatively rare subject in Poelenburgh's oeuvre.[1] The artist must have painted this picture shortly after his return from Italy, when his impressions of its artistic traditions were still strong. The figures in the Italianate landscape are clearly inspired by Raphael. The iconography is conventional: the Madonna in a raised position is holding the Christ child who is blessing the three kings, representing the three parts of the known world, Europe, Asia, and Africa. This representation, together with the angels in the sky and the ruin in the background, which symbolizes the decay of the heathen world, conforms to the established pictorial tradition both in Italy and in the Netherlands. The only unusual feature is the prominent figure of St. Joseph, who is reading a book, probably representing the gospels.[2] Joseph as a scholar, reading a book, was a relatively new concept, first introduced in representations of the Holy Family by Flemish painters at the beginning of the sixteenth century, notably by the Master of the Holy Blood, Joos van Cleve, and Marcellus Coffermans.[3] While Joseph's noble figure is derived from Raphael, his act of reading signifies Poelenburgh's familiarity with Flemish religious painting.

1. For other examples see Brulhart 1978.
2. A similar representation of Joseph reading a book is found in Poelenburgh's *Adoration of the Shepherds* in the Alte Pinakothek, Munich (inv. no. 221). The new type of Joseph as scholar and teacher, substituting for the traditional figure of the humble carpenter or performer of menial tasks, was the result of a reappraisal of the role of the saint by church scholars in the fifteenth century, particularly Jean Gerson (d. 1429).
3. One of the paintings by Marcellus Coffermans, *The Holy Family*, showing Joseph reading a book, is in the Bass Museum of Art, Miami Beach, one of the venues of this exhibition.

PIETER GERRITSZ VAN ROESTRATEN

Dutch, 1627–1698

Born in Haarlem, Pieter Gerritsz van Roestraten studied with Frans Hals and, in 1654, married Ariaentje, the daughter of his teacher. In his later career he was active in London, where he died. Roestraten painted genre scenes reminiscent of Jan Steen, but his mature work consists mainly of still lifes, distinguished by their quiet dignity and restraint.

32. Still Life with Tea Service

Signed lower center: *P. Roestraten*
Canvas, 46 × 61.5 cm
Jakob Briner Foundation, Winterthur
Provenance: Auction F. Muller, Amsterdam, 7 May 1953, no. 253
Literature: Wegmann (forthcoming)

Five china porcelain cups, a silver platter and silver spoon, a silver gilt ewer, an earthenware teapot, and a few lumps of sugar are displayed on a polished table top, ready for the serving of tea. Taking tea had become customary in Holland during the second half of the seventeenth century when the East India Company increased trade with China and Japan. Not only the tea but also the porcelain tableware were much valued imports from China. The decorated red earthenware teapot, a type originally from Yi-hsing, was probably one of the imitations manufactured in Delft, called *rode Delftse trekpotjes*.[1] Roestraten painted this teapot repeatedly, with or without the cupid figure on top of the lid.[2] Identical china cups, too, appear in several of his still-lifes.[3]

The composition, with its austere simplicity and brilliant observation of detail (see the brown layer of tea in the partly filled cups!) does not share the decorative tendencies of late seventeenth-century Dutch painting but is closer to the intimate still-life concept of Adriaen Coorte.

1. One of the most renowned Delft manufacturers was Ary de Milde, called "Theepotbacker" (see C.H. de Jonge, *Delfter Keramik,* Tübingen, 1969, pp. 64, 67).
2. Berlin, Staatliche Museen, no. 2010; Rotterdam, Museum Boymans-van Beuningen, inv. st. 131; Louvre, M.N.R. 780 (without the Cupid figure).

3. For instance, in the painting in Berlin cited in note 2 above.

Jacob van Ruisdael

Dutch, 1628–1682

Born in Haarlem, Jacob van Ruisdael probably first trained with his father, Isaac, and perhaps with his uncle Salomon van Ruysdael who greatly influenced his work. Another early influence was the landscape painter Cornelis Vroom. In 1648 Ruisdael joined the Haarlem Guild of St. Luke, and in 1651 he made a journey to Germany in the company of Nicolaes Berchem (q.v.), where both artists made paintings of the Castle of Bentheim. About 1656 he moved to Amsterdam, where Meindert Hobbema (q.v.) became his pupil. Ruisdael painted every type of landscape, including marine and winter scenes. His panoramic views of fields and dunes often include, along the horizon, the profile of the city of Haarlem. Ruisdael raised the art of landscape painting to new heights; he also produced a series of etchings and a large number of drawings.

33. Landscape with a Waterfall

Signed lower left: *JvRuisdael* (JvR in ligature)
Canvas, 65.5 × 53.5 cm
Jakob Briner Foundation, Winterthur
Provenance: Jan van der Linden van Slingeland, Dordrecht, auction 22 August 1785, no. 344 (300 fl. to Beekman); Prince de Talleyrand, Paris, auction 7 July 1817, no. 26 (this auction did not take place since the whole collection was acquired by W. Buchanan – or by Gray & Allnutt, according to Smith); Count Pourtales, London; John Smith and Thomas Emmerson, 1826; H.D. & A. Seymour, Knoyle House, Hindon, Wilts.; Christie's, London, 19 January 1945, no. 93 (to Duits, London); Sir Alexander Walker; Christie's, London, 4 May 1951, no. 33 (to Nicholas Argenti); Mrs. Anne Conran, Cardiff; Harari & Johns, London, 1985; Galerie Sanct Lucas, Vienna, cat. 1985/86, no. 15; acquired 1986
Literature: Smith 1835, vol. 6, no. 42; Waagen 1857, supp., p. 386; Hofstede de Groot (1911), nos. 336 and 378a; Wegmann 1986, pp. 15–17
Exhibitions: National Museum of Wales, Cardiff (on loan, 1975–1985)

Waterfalls do not occur in the flat countryside of Holland, but the Amsterdam painter Allaert van Everdingen, returning from a journey in Scandinavia, introduced the subject to mid-seventeenth-century Dutch landscape painting. Jacob van Ruisdael repeatedly painted waterfalls from the 1650s onwards. His interpretation of the theme, however, in contrast to Van Everdingen's more prosaic approach, is an intense evocation of the forces of nature.

The Briner painting, with its vertical format, has many compositional similarities with the powerful *Waterfall with Castle and a Hut*, c. 1665, in the Fogg Art Museum, and with related versions.[1] Compared with the Fogg painting, the Briner version, with its brighter sky reflected in the calm water above the rocky cascade, and the peaceful shepherd and sheep on the hilly bank at the right, has a more tranquil aspect. The painting probably dates from c. 1670, marking the transition from the dynamic waterfalls of the 1660s, in vertical format, towards the calmer and more serene compositions of the 1670s, usually in horizontal format.[2]

It has generally been accepted that Ruisdael's waterfalls, which are not observed from nature, carry a symbolic message. The waterfall was a traditional symbol of the transitoriness of human life.[3] The fallen tree on the right is a *vanitas* symbol frequently used by Van Ruisdael, here reinforcing the waterfall's message of mortality. Jan Luyken, in an emblem, contrasted the (wordly) turmoil of the waterfall with the silence of God.[4] This contrast is here illustrated in the church on the hill calmly dominating the restless rush of the waterfall below. The church on a rock is a symbol of salvation, and the shepherd with his sheep in this context could also be an allusion to Christ the Good Shepherd.

1. For an illustration and a list of versions see Amsterdam 1987, cat. no. 85.
2. Ibid; and ms. letter from Seymour Slive, 30 June 1986, to the Briner Foundation, confirming a date in the early 1670s.

3. Wiegand 1971, pp. 87 ff.
4. Amsterdam 1987, no. 85, n. 9.

95

RACHEL RUYSCH

Dutch, 1664–1750

Born in Amsterdam, the daughter of the distinguished professor of anatomy Anthony Fredericus Ruysch, Rachel Ruysch studied with the flower painter Willem van Aelst. In 1693 she married the portrait painter Juriaen Pool, and in 1701 she and her husband joined the Guild of St. Luke at The Hague. In 1710 she was appointed court painter to the Elector Palatine at Dusseldorf. From 1716 she lived again in Amsterdam, where she died. Rachel Ruysch was the most celebrated flower painter of the late seventeenth and early eighteenth centuries. Her fame was eclipsed only by Jan van Huysum (1682–1749), whose vividly colored flower pieces, painted against a light background, became the fashion in the eighteenth century and beyond.

34. Vase of Flowers

Signed lower right: *R. Ruysch*
Canvas, 62 × 49 cm
Geneva, Musée d'Art et d'Histoire, inv. no. CR 137
Provenance: Collection G. Revilliod; legacy G. Revilliod, 1890
Literature: Hofstede de Groot, vol. 10 (1928), p. 312, no. 20; Gielly 1937, p. 20; Bénézit 1962, vol. 7, p. 444
Exhibition: Neuchâtel 1953

On a table stands a dark vase with a bouquet containing a yellow and a red tulip, three roses (two light red, one white), a deep yellow carnation, one white and one yellow anemone, one yellow and three brown nasturtiums, and two white zinnias. These flowers bloom at different times of year and were not painted from nature but, as was customary in the seventeenth century, from studies the artist made from life. The flowers are presented in a carefully thought-out "casual" arrangement. The diagonal sweep from the lower left to the upper right corner of the bouquet is continued towards the lower left by the folds and fringe of a tablecloth. The firm horizontal lines of the table top balance the design.

Rachel Ruysch continued to use the chiaroscuro effects of earlier seventeenth-century Dutch painting, highlighting her flowers dramatically against a dark, unspecified background. She painted a number of versions of this composition.[1]

1. Grant 1956, cat. no. 56, pl. 1 and cat. no. 75, pl. 4. See also Bernt 1960, fig. 696.

HERMAN SAFTLEVEN

Dutch, 1609–1685

Born in Rotterdam as the son of a painter and art dealer, Herman Saftleven had two brothers, Abraham and Cornelis, who were also painters. In 1632 he moved to Utrecht, where he lived until his death. In the 1630s he painted genre scenes and still lifes in the style of his older brother Cornelis, but from c. 1640 he specialized in landscape. From 1650 he produced, almost exclusively, views of the Rhineland, painted on a small scale. Many of these views are imaginary but based on scenery observed during his extensive travels along the Rhine and the Mosel.

Herman Saftleven

35. Rhineland Fantasy: Landscape with a Votive Column
Illustrated p. 101

Signed with monogram: *HS 166* [?] (HS in ligature); inscribed on the verso: *Duits gesicht/Herman Saftleven f Utrecht./Ann° 1660*

36. Rhineland Fantasy with Boats at Anchor
Illustrated p. 100

Signed with monogram: *HS 16*[??] (HS in ligature)

Pendants: Panel, 28 × 38 cm (each)
Jakob Briner Foundation, Winterthur
Provenance: Christie's, London, 17 March 1939, no. 100 (as pendants)
Literature: Wegmann (forthcoming)

From c. 1650 Saftleven made regular excursions to the Rhineland, where he was attracted to the picturesque rocky shores of the river between Koblenz and Mainz. Some of the many drawings he made of the region are preserved in the famous Atlas Blaeu in the National Library, Vienna.[1] Saftleven's topographical sketches provided motifs for the artist's paintings of the Rhineland, many of which bear inscriptions and dates on the verso, some autograph and some by other hands. A great number of his paintings are composite views of topographical motifs arranged in imaginary settings. These imaginary scenes were usually described with the summary term *Duits gesicht*.[2]

The composition of these fantasy landscapes, relying on a high vantage point with a sweeping view over ragged mountain ranges, opening up to a valley that recedes into the far distance, is rooted in the tradition of the mountainous landscapes by Pieter Bruegel the Elder and his later followers, e.g. Jan Brueghel the Elder (cf. cat. no. 10), Joos de Momper and others.

In both paintings, Saftleven has given much attention to the meticulously executed staffage. The votive column with pilgrims in prayer is a motif reminiscent of Joos de Momper. Both shipping and farming activities are featured in the first painting in genre-like detail, whereas the pendant scene concentrates on the transportation of goods from the river to the shore.

Although clearly intended as pendants, the two pictures may have been painted at different dates. Only number 35 can be dated 1660 with some assurance, according to the inscription on the verso, while number 36 may have been painted earlier, since the third digit in its illegible date does not appear to be a 6.

1. Dattenberg 1967, p. 287ff.

2. See Schulz 1982, no. 138.

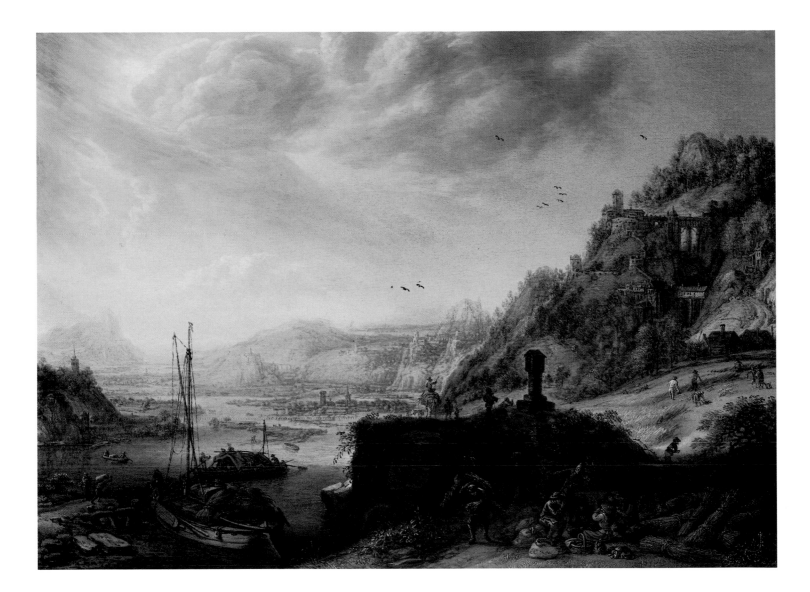

ROELANDT SAVERY

Dutch, 1576–1639

Born in Kortrijk (Courtrai) in Flanders, Roelandt Savery moved with his family to Haarlem in 1580. Roelandt's teacher was his elder brother Jacob (1565–1603), who joined the Haarlem Guild of St. Luke in 1587. In 1591 the two brothers moved to Amsterdam, and after Jacob's death in 1603, Roelandt worked at the court of the emperor Rudolf II in Prague. While in the emperor's employ, Roelandt toured the Alps and the Tirol, c. 1606–1608, painting and drawing landscape and mountain views. After Rudolph's death in 1612, Roelandt became court painter to the emperor Matthias in Vienna. In 1619 he established himself in Utrecht, becoming one of the city's most successful artists. Savery painted flower pieces, animals, and genre scenes, but he is particularly renowned for his wooded landscapes, often featuring European or exotic animals and birds. His style remained Flemish in character, reflecting the influence of Gillis van Coninxloo and of fellow artists of the "School of Prague", particularly Jan Brueghel the Elder (q.v.) and Pieter Stevens.

37. *Wooded Landscape with a Wooden Bridge*

Signed and dated lower left: *SAVERY 1607*
Panel, 49 × 70 cm
Geneva, Musée d'Art et d'Histoire, inv. no. CR 144
Provenance: Collection Gustave Revilliod; legacy G. Revilliod, 1890
Literature: Brulhart 1978, n.p.; Da Costa-Kaufmann 1985, p. 273, cat. no. 19-14; Müllenmeister 1988, cat. no. 29, text pp. 14, 15, 72, 74

The painting dates from the period of Savery's travels in the Tirol and features a view at the foot of the Alps. Beyond two groups of lofty trees, linked by a rickety wooden bridge, a vista opens into a light-filled valley with a castle. The bright sunlight reflected from the surface of a river, like the pale blue sky in the distance, contrasts sharply with the heavy brown foliage and tree trunks in the frontal

plane. This compositional scheme, with its abrupt changes of plane, is characteristic of the late Mannerist style of landscape painting practised by artists of the Rudolphian circle at Prague. The staffage, consisting of figures around the bridge and two herons and a donkey in the middle distance, is carefully drawn.

The painting is based on a drawing in the Bibliothèque Royale, Brussels (inv. no. 511).[1] The figure on the left of the peasant in a fur hat, peeling an apple, seems to have been modelled on drawings by Pieter Bruegel the Elder.[2] Similar compositions are the *Schleissheim Eichenwald* in Munich, the *Wooded Landscape with Deerhunt* in Bamberg, and the *Tirolean Landscape (Flight into Egypt)* in Leningrad.[3]

1. Müllenmeister 1988, p. 200.
2. Ibid., p. 201.

3. Ibid., cat. nos. 43, 101, 28.

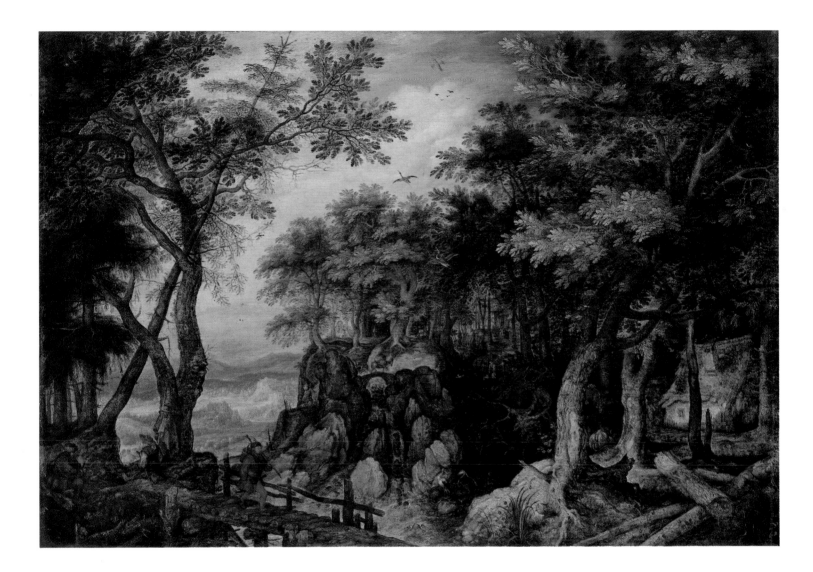

HENDRICK SORGH

Dutch, 1609/11–1670

Hendrick Sorgh was born and, as far as is known, spent all his life in Rotterdam. Nevertheless, according to Houbraken, he studied with the Flemish genre painter David Teniers and with the Haarlem artist Willem Buytewech. In 1659 Sorgh was hoofdman (head) of the Guild of St. Luke in Rotterdam. He had a high reputation as an artist and also held several prestigious municipal positions. Sorgh specialized in peasant interiors close to the manner of Teniers and Adriaen Brouwer. His work is also reminiscent of genre scenes by Adriaen and Isaack van Ostade. After 1650 Sorgh added market scenes to his repertoire, and occasionally he painted portraits and marine history subjects.

38. Kitchen Scene

Panel, 48.5 × 43.5 cm
Jakob Briner Foundation, Winterthur
Provenance: Duits, London; Collection Mildmay-White; Christie's, London, 19 April 1985, lot 89; Galerie Sanct Lucas, Vienna, cat. 1985/86, no. 11; acquired 1986
Exhibitions: Plymouth 1970, no. 83 (as Van Slingeland)
Literature: Wegmann 1986, pp. 20, 21

In a lofty kitchen interior a young scullery maid, plucking a duck, is interrupted in her work by a fishmonger who offers her a basket of herrings. A cat has been attracted to the fish. In the right background a woman is standing in a doorway on top of a flight of stairs; she is obviously eaves-dropping on the two young people. A sumptuous still life of vegetables, fruit, a copper kettle, a stoneware jug, and a porcelain platter with Chinese decorations, fills the corner in the right foreground. A birdcage hangs from the high ceiling and a candle is held in a bracket on the mantelpiece. The scene reminds one of later paintings by Nicolaes Maes of housewives who eavesdrop on the amorous pursuits of their servants.[1] All the objects conspicuously surrounding the pair could be understood by contemporary viewers as symbols of love or lust. The fish, the cat, the dead bird, as well as the live bird in a cage, even the onions and the candle, had erotic connotations.[2]

1. See Philadelphia 1984, cat. no. 67.

2. Amsterdam 1976, cat. no. 40; Philadelphia 1984, cat. nos. 33, 65, 67. See also Wegmann 1986, pp. 20–21.

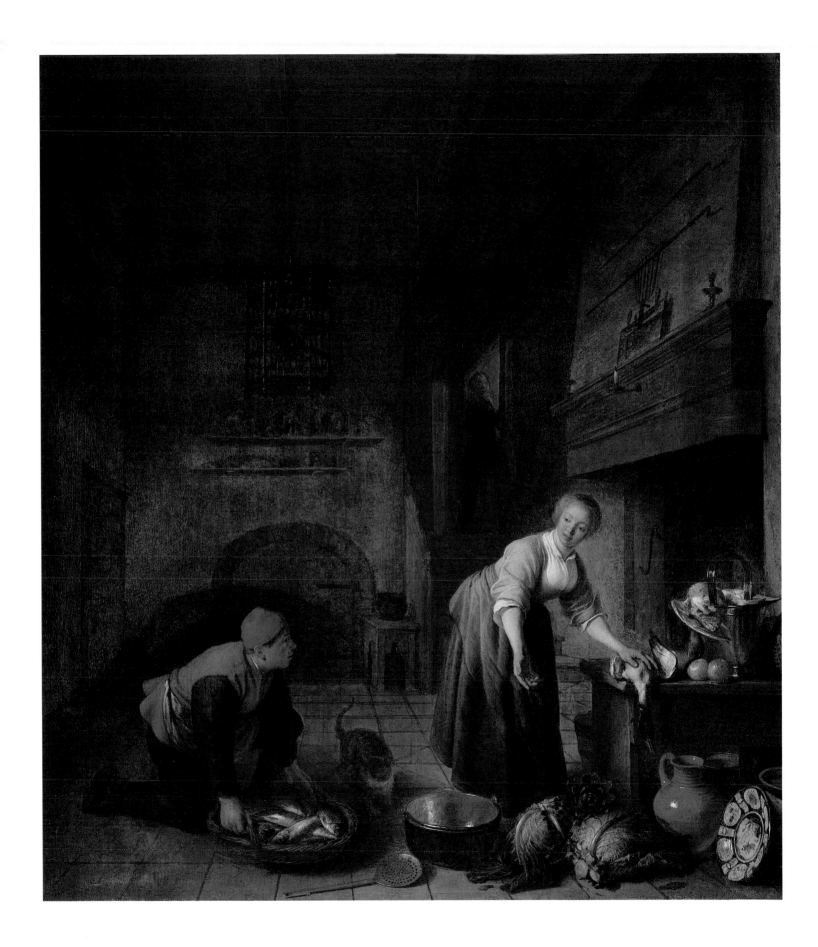

HENDRICK SORGH

39. The Village Surgeon

Signed on the painted document, upper left: *HM Sorch* (HM in ligature)
Panel, 50 × 65 cm
Jakob Briner Foundation, Winterthur (on loan)
Provenance: Christie's, London, 22 July 1988, no. 110

The picture features the shop of a village barber, who in the seventeenth century also carried out the function of a surgeon.[1] A peasant is undergoing the torture of a leg operation; his twisted features register the pain of this procedure. Various tools and implements belonging to the barber-surgeon's trade form a still-life-like arrangement resembling an alchemist's kitchen.[2] The Latin inscriptions on stone jars, the presence of a few books, the anatomical-study print displayed on the wall, all testify to the surgeons's theoretical knowledge of his subject. The skull and bones on the left could also be understood as material for medical study.

Paintings of doctors in Dutch art range from serious studies of prominent physicians (Rembrandt's *Anatomy Lesson of Dr. Tulp,* 1632) to depictures of village quacks. Sorgh's composition, despite the many scientific attributes shown, has more in common with the latter. His scene includes an owl, traditionally a symbol of wisdom but in the seventeenth century associated also with quackery,[3] and the skeleton of an ape. These motifs, which may have been inspired by Adriaen Brouwer's and David Teniers the Younger's paintings of similar subjects, indicate that Sorgh's theme is quackery rather than serious medical practice.

The painting is an early work, comparable in style to Sorgh's *Merry Company* in Worcester, Massachusetts.[4] The form of signature, *Sorch,* indicates an origin before the 1640s.[5] The compositions is representative of the Rotterdam school of peasant genre. The dimly lit, barn-like interior, with an accumulation of objects in the foreground, shows the influence of François Ryckhals, who introduced this type of composition to Rotterdam.[6] Adriaen Brouwer and David Teniers the Younger painted similar interior spaces.

1. Adriaen Brouwer's painting of *A Village Barber's Shop* (Munich, Alte Pinakothek) shows both a surgeon and a barber at work in the same interior.
2. Sorgh painted an alchemist's kitchen at least once (see Schneeman 1982, cat. no. 20).

3. B. Schnackenburg, *Flämische Meister in der Kasseler Gemäldegalerie,* Kassel, 1985, pp. 46ff.; Renger 1986, p. 68.
4. Schneeman 1982, cat. no. 4.
5. Ibid., pp. 52ff.
6. See Haak 1984, p. 408, fig. 881.

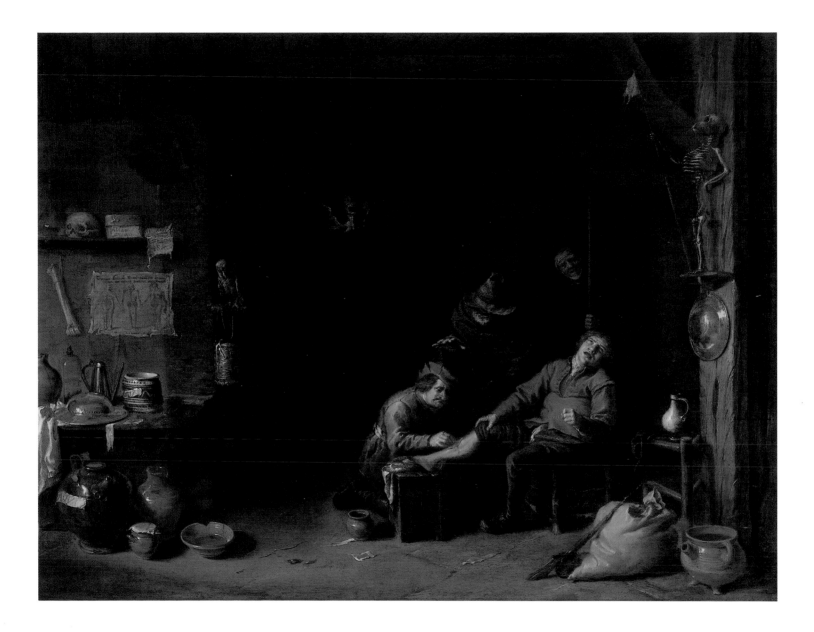

JURIAEN VAN STREECK

Dutch, 1632–1687

Juriaen van Streeck was born and spent all his life in Amsterdam. Little is known about his life and nothing about his training. His oeuvre is small, but his carefully constructed, understated still lifes, usually featuring a few costly objects, show the influence of Willem Kalf. Van Streeck's paintings are of high quality and much appreciated by connoisseurs.

40. Still Life with "Ming" Vase

Signed indistinctly lower left: *JvS...*
Panel, 42.5 × 33.5 cm
Jakob Briner Foundation, Winterthur
Provenance: Christie's, London, 14 July 1950, no. 149
Literature: Wegmann (forthcoming)

A table top, partly covered by a red velvet cloth with gold fringe, holds a display of fruit and precious objects. The tall imitation Ming vase of Delft manufacture, placed off-center, dominates the composition; its strong vertical is balanced by the horizontal of the tabletop and by the slightly tilted bowl of Delft Fayence ware.[1] The diagonal movement of the bowl is continued by the handle of a knife and together they provide a counter movement to the diagonal sweep of the gold fringe. The delicate reflections in a crystal vessel animate the dark background.

This painting is an example of the *pronk-stilleven* – a still life of sumptuous objects – that in the second half of the seventeenth century superceded the earlier, simpler "breakfast piece". While earlier still lifes often had a *vanitas* message, the type of painting here seen served to illustrate the costly possessions, often of exotic origin, of the wealthy Dutch burgher class.

1. The bowl appears in several other still lifes by Van Streeck (see Bernt 1979, no. 806; Bol 1982, fig. 289; and Lakenhal Museum, Leiden).

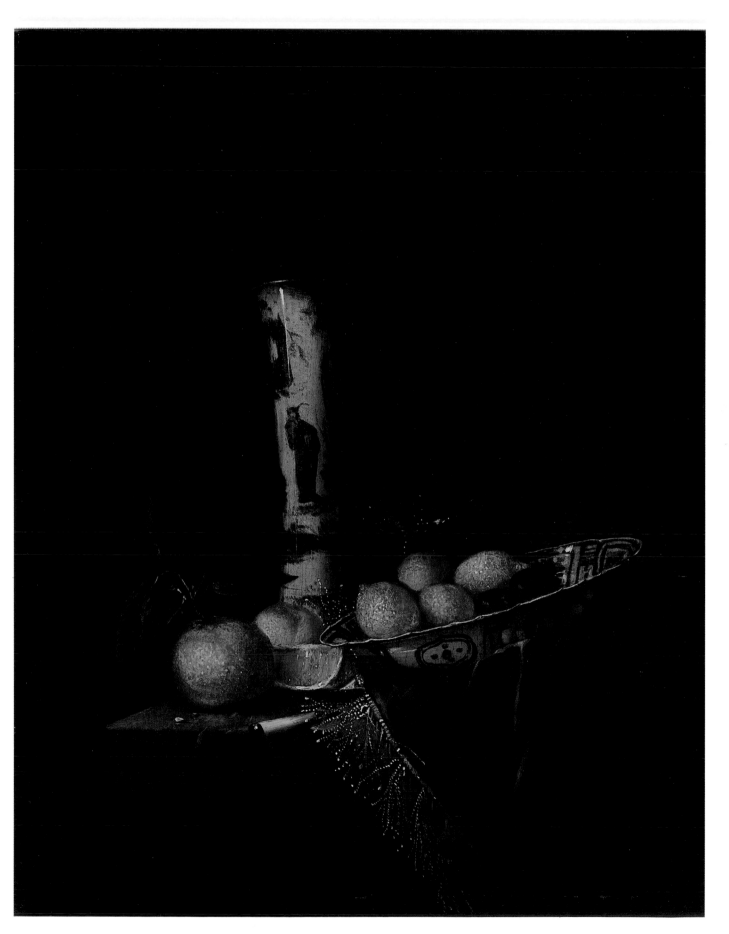

ESAIAS VAN DE VELDE

Dutch, 1587–1630

*B*orn in Amsterdam, Esaias van de Velde may have studied there with Gillis van Coninxloo and possibly with David Vinck-
boons, whose influence is noticeable in his work. In 1610 Esaias settled in Haarlem where he joined the Guild of St. Luke in
1612. He belonged to a group of Haarlem artists, including his cousin Jan van de Velde, Willem Buytewech, Hercules Segers, and
Claes Jansz Visscher, who pioneered the development of realism in Dutch landscape painting. In 1618 he moved to The Hague, where
he joined the Guild and remained for the rest of his life. Esaias van de Velde painted genre scenes, cavalry battles, and highway rob-
beries, but he is most renowned for his landscapes, including winter scenes. His oeuvre includes drawings and etchings.

41. Cavalry Battle

Signed and dated on the bridge, lower center: *EVVELDE 1623*
Panel (tondo), 18 cm diameter
Jakob Briner Foundation, Winterthur
Provenance: Auction Fred Muller, Amsterdam, 7 May 1953, no. 268

In 1621, three years after Esaias settled in The Hague, the
Twelve Years Truce between Spain and the Northern
Provinces came to an end. The renewal of hostilities
prompted artists, particularly those close to the *stadhou-
der's* court in The Hague, to paint battles and military sub-
jects. Scenes of cavalry engagements enjoyed a vogue, and
Esaias in the 1620s produced a series of paintings and draw-
ings of this subject.[1]

The *Cavalry Battle* in the Briner Collection belongs to a
group of similar small-scale paintings, dated from 1622. The
picture is most closely related to the *Cavalry Battle* in the
Suermondt-Ludwig Museum, Aachen.[2] A rearing white
horse and its rider, set against a group of trees, similarly fea-
ture on the left in both paintings. Two other panels of 1622
showing cavalry engagements, in the Gemäldegalerie Des-
sau,[3] are also similar in composition.

The Briner painting is the only one to show the cavalry
scene in a tondo format. A large number of horsemen are
galloping from the center towards the left, and a smaller
contingent moves towards the right, both groups crushing
the bodies of dead enemies under their horses' hoofs. A
shallow bridge across a narrow canal provides a horizontal
platform for the figures within the tondo. The vigorous
centrifugal movement of horses and riders counteracts the
classical balance of the tondo format in favor of characteris-
tic Baroque dynamism.

1. Keyes 1984, cat. nos. 20–43.
2. Ibid., cat. no. 20, fig. 437.

3. Ibid., cat. nos. 23, 24; figs. 281, 282.

WILLEM VAN DE VELDE THE YOUNGER

Dutch, 1633–1707

*T*his artist, born at Leiden, was the son of the renowned marine painter and draftsman Willem van de Velde the Elder (1611–1693). By 1636 the family had settled in Amsterdam. Willem the Younger trained under and continued working with his father until the latter's death. In the 1650s he seems to have had close associations with Simon de Vlieger and Jan van de Cappelle, who both greatly influenced his development as a marine painter. The French invasion of Holland in 1672 made life more difficult for Dutch artists and prompted the move of both Van de Veldes to London where they were appointed as marine painters to the court of Charles II. They stayed in England to the end of their lives, running a large studio and painting marine battles and other marine subjects. The Younger (as he is usually called) owed his accuracy in painting ships and everything pertaining to navigation to the unrivalled skill and technical expertise of his father. While the Elder specialized in ship drawings and large grisailles ("penschilderijen"), the Younger produced paintings that combined a faultless rendering of ships and their manoeuvres in wind and weather with sensitively observed marine scenery.

42. Shipping off the Shore in a Light Breeze

Signed on a stake, lower left: *W.V.V.*
Canvas, 32 × 39.5 cm
Jakob Briner Foundation, Winterthur
Provenance: The Manisty family; Christie's, London, 5 July 1985, no. 51; Galerie Sanct Lucas, Vienna, cat. 1985/86, no. 17; acquired 1986
Literature: Wegmann 1986, pp. 23–24; Robinson (forthcoming), cat. no. 185 (2)

The peaceful shipping scene with its low horizon, dominated by a sky filled with cumulus clouds, is representative of the best of Dutch marine painting in the second half of the seventeenth century. The few simple boats provide an accent and focus to a composition basically concerned with nature.

Willem van de Velde paid meticulous attention to the correct depiction of the humble coastal craft and their manoeuvres. On the right are two small fishing boats of the type called *weyschuit*[1] and a man standing on the water's edge, looking out to sea. A few wooden stakes in the left foreground serve as a repoussoir. In the left middle distance a large *kaag*, loaded with hay, is seen sailing in a light breeze, with a small boat close alongside. In the center background is a small threemaster at anchor, or about to anchor; she is firing guns to port and to starboard. Figures of sailors busy at various tasks are seen on all the ships.

Willem van de Velde the Younger was a master of ship perspective, a difficult discipline that he had learned from his father, the first marine painter to demonstrate a full grasp of the subject.[2] The scale of ships corresponds correctly to their actual size and their distance from the horizon. Relatively few marine painters of the seventeenth century and later fully understood the complex system of perspective related to ships in the open sea.

The picture is close in style to Van de Velde's painting at Ham House, London, signed and dated *in Londe 1673* (Robinson, no. 48). Dutch shipping scenes of this kind had a great appeal to the Van de Veldes' new clientele in England, and it is not surprising that their large studio produced many repetitions or versions of the most popular compositions. The present picture exists in seven versions, with the painting at Petworth, England (Robinson, no. 185/1) probably painted entirely by the master, while subsequent versions were produced by the studio with various degrees of the master's participation. The Briner version is designated no. 2 of the series in Robinson's catalogue, signifying a quality close to the key picture at Petworth (no. 1). Later copies of the picture were made by English artists in the eighteenth and nineteenth centuries.

1. For a description of this and other ship types see Robinson 1973, vol. 2, app. 4.
2. De Vlieger used to be credited with "inventing" marine perspective because of a drawing he made in 1645 (British Museum 1874, 8.8.99).

However this drawing only reflects the successful experiments made by the elder Willem van de Velde from 1643 (see Robinson, forthcoming, introduction).

HENDRICK VAN VLIET

Dutch, 1611–1675

Hendrick van Vliet was born in Delft where he trained with his uncle, the portrait painter Willem van Vliet. He joined the Delft Guild of St. Luke in 1632. His early works are portraits in the style of his uncle. From about 1650 he specialized in views of church interiors, mostly of the Old Church or New Church of Delft. Van Vliet carried on the tradition of architectural painting in Delft after 1652, when both Gerrit Houckgeest and Emanuel De Witte (q.v.) had left the city and while Jan Vermeer and Pieter de Hooch were active there.

43. Interior of the Oude Kerk, Delft

Signed and dated on the base of the central column: *V. Vliet Ao 1669*
Panel, 53 × 41 cm
Jakob Briner Foundation, Winterthur
Provenance: Collection Alexander Tritsch, Vienna; Auction Cassirer & Helbing, Berlin, 5 December 1929, no. 37; Dorotheum, Vienna, 27–29 April 1933, no. 217; Christie's, London, 18 May 1951, no. 132
Literature: Glück 1907, no. 28; Jantzen 1910, cat. no. 543, text. p. 106; *Der Cicerone* 1929, p. 658; Liedtke 1982, cat. no. 86, text p. 108; Wegmann (forthcoming)

This is a view across the nave of the Oude Kerk in Delft towards the chancel in the east. The tall columns dominate the composition. A fluctuating play of light and shade animates the interior space. It should be noted that light comes from two opposite directions, falling strongly from the west on columns, vaults and walls, and filtering through the east windows, casting reflections on the floor. The use of light to heighten architectural elements was important to this artist, who, following the example of Houckgeest and De Witte, abandoned the central perspective view along the nave favored by earlier painters of church interiors.[1] A mother and her child are sitting on the floor, facing an open tomb with scattered bones and skulls. This *memento mori* is reinforced by the diamond-shaped mourning plaques attached to the columns.

1. See for example the church interior by Pieter Neeffs the Elder, no. 25 in this catalogue.

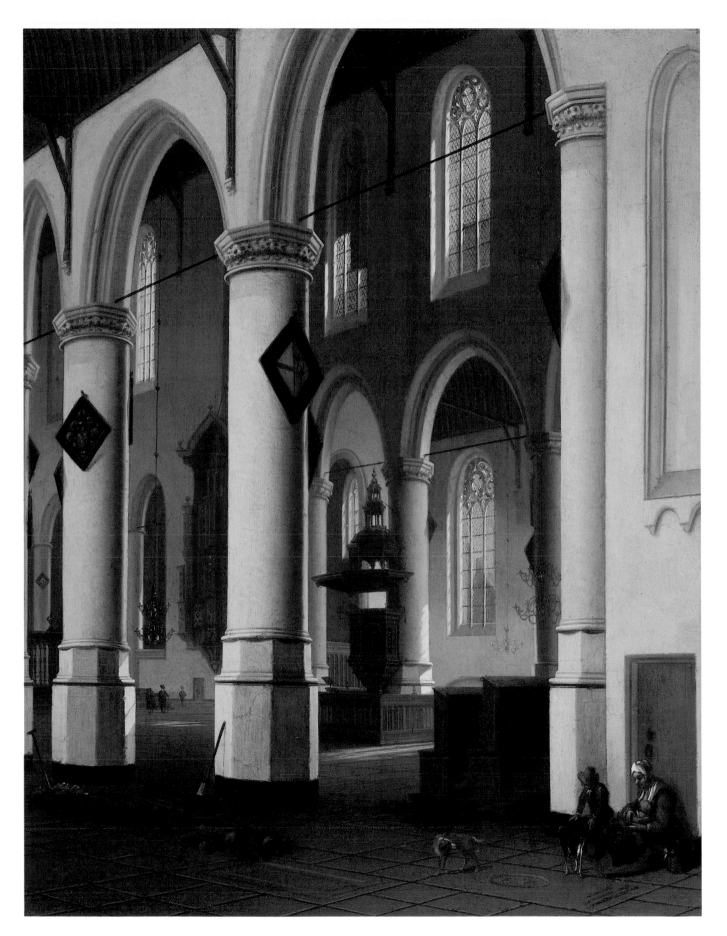

EMANUEL DE WITTE

Dutch, 1615/17–1691/92

Emanuel de Witte was born in Alkmaar, where he was a member of the Guild of St. Luke in 1636. In 1639 and 1640 he was in Rotterdam, and from 1641 to 1651 he lived in Delft, joining the Guild in 1642. In 1652 he moved to Amsterdam, staying for the rest of his life. During his early career De Witte painted portraits and history subjects, but from c. 1650 he specialized in church interiors, simultaneously with Gerrit Houckgeest. The repertoire of his later career also includes fanciful harbor views, market scenes, and a few domestic interiors.

44. The Nieuwe Kerk in Delft with the Tomb of William the Silent

Signed lower left: *ED...* (remainder of signature illegible)
Panel, 107.5 × 90.5 cm
Jakob Briner Foundation, Winterthur
Provenance: C. W. Clarke, Bridwell; Auction Lewis Fry et al., London, 10 March 1922 (?); Galerie Fischer, Luzern, 17 June 1958, no. 3048; Galerie Heinemann, Wiesbaden; Galerie Koller, Zurich, auction May/June 1969, no. 2236; Galerie Kurt Meissner, Zurich; acquired 1972
Literature: Manke 1963, no. 24, fig. 11; Wheelock 1975/76, p. 170, n. 14; Liedtke 1982, no. 250, fig. 2, text pp. 13–15; Wheelock 1986, p. 170; Wegmann 1986, pp. 25–27

A green curtain is drawn to the right across a fictitious curved frame to open an oblique view into the choir of the Nieuwe Kerk (New Church) in Delft. The scene focuses on the tomb of William the Silent, surrounded by a group of elegant figures. A man leading a child approaches from the left. Three dogs in the foreground enliven the composition.

The tomb of William the Silent, designed and built by Hendrick de Keyser in the years 1614 to 1621, was revered by the Dutch as a symbol of their liberation from Spanish domination. William the Silent, the founder of the House of Orange, had been the first leader of the resistance against Philip II of Spain after the Dutch revolt broke out in 1568. He was murdered in Delft in 1584 and became a national hero. The Eighty Years War of the Northern Provinces against Spain came to an end in 1648. Two years later, in 1650, William II died prematurely and, like the preceding members of the Orange dynasty, was buried in the Nieuwe

Kerk. His sudden death resulted in a demand for pictures of his grandfather's monument, which was frequently the subject of paintings from c. 1650.[1]

Gerrit Houckgeest appears to have been the first painter to treat the subject, with his painting in Hamburg.[2] De Witte and Hendrick van Vliet (q.v.) soon followed, not only in the choice of subject but also in developing a new style of church painting, emphasizing the human interest and dwelling on the optical effects of strongly contrasting light and shade. The character of these new "Delft School" church paintings is entirely different from the strictly architectural compositions of the Flemish school (see, for example, cat. no. 25) and is more colorful and intimate than the imposing views of church interiors by Pieter Saenredam. Warm sunlight filters through the windows, animating surfaces in a lively interplay of light and shade.

The Briner painting has been dated c. 1651 but the costumes belong to a period between 1655 and 1665.[3] The attribution to De Witte, made by Manke and Liedtke, is controversial: it has been rejected by Wheelock,[4] who argues that the quality of execution falls below De Witte's usual standard. The painting, indeed, lacks the precision and assurance of De Witte's autograph manner. Notwithstanding these problems, the picture belongs to the distinctive group of architectural paintings from Delft in the second half of the seventeenth century.

1. For the significance of the Tomb of William the Silent, and for an up-to-date appraisal of De Witte's development as a painter of church interiors, see Wheelock 1975/76, p. 167ff.
2. Hamburg, Kunsthalle, no. 342, signed and dated 1650.
3. Information kindly supplied by Avril Hart, costume historian at the Victoria and Albert Museum, London.

4. Wheelock 1986, p. 170. Wheelock also rejects three other versions of the painting (Liedtke 1982, figs. 20, 21, 22), suggesting that all four paintings may be by Van Vliet. The condition of the Briner painting, which has suffered damage, makes it difficult to arrive at a reliable attribution. During a recent restoration in 1987, however, traces of De Witte's typical signature have been found.

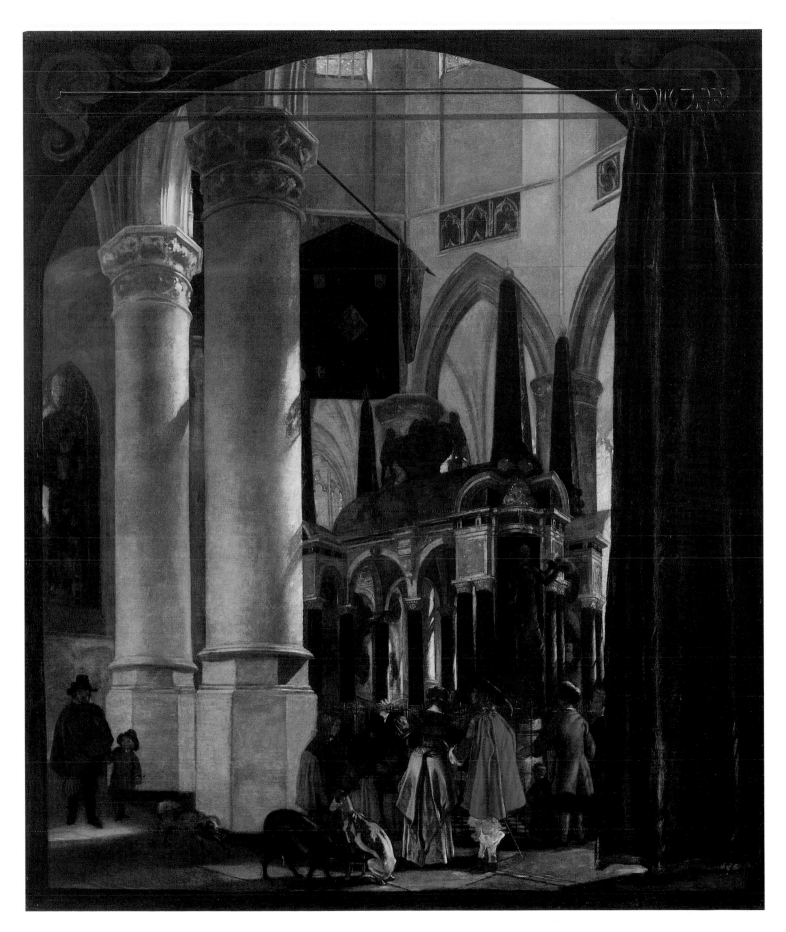

117

PHILIPS WOUVERMAN
Dutch, 1619–1668

The son of the painter Paulus Wouverman, Philips Wouverman was born and spent his life in Haarlem. His first teacher was probably his father, and, according to Cornelis de Bie ("Het Gulden Cabinet"), he studied with Frans Hals. In 1640 he became a member of the Haarlem Guild of St. Luke and was one of its officers in 1645. Wouverman was a prolific artist, specializing in landscapes, which usually feature scenes with horses, such as battles, hunts, or riders resting at an inn. Only a few of his landscapes include religious or mythological subjects. His style was influenced by Pieter Verbeecq, a painter of horses, and by Pieter van Laer (called Bamboccio), the pioneer of Italianate subjects in Haarlem. Wouverman had many followers, and the popularity of his paintings lasted well into the eighteenth century, when they had a particular appeal for French collectors.

45. Halt at the Inn

Signed lower right in monogram: *PHILS W.* (PHILS ligated)
Canvas, 66 × 83 cm
Geneva, Musée d'Art et d'Histoire, inv. no. 1942-30
Provenance: Collection Jacob Duval, 1804; Collection G. Favre-Bertrand; bequest Guillaume Favre, 1942
Literature: Rigaud 1876, p. 334; Hofstede de Groot, vol. 2 (1908), no. 423; Deonna 1943, p. 166, no. 5; Brulhart 1978, n.p.

A group of travellers has stopped outside an inn called The Swan, according to the sign above the door. The inn and its outbuildings fill the space on the right. A prominent tree serves to soften the contours of the building, and its branches provide a decorative foil against the sky. On the left the view opens towards a plain and the light-filled far horizon.

The focal point of the composition is the white horse, held by a groom. The silvery sheen of its coat adds a vibrant highlight to the surrounding colors. A white horse appears in so many of Wouverman's paintings that it has become almost a second signature. Other contemporary Dutch painters, for instance Isaack van Ostade, placed white horses in their landscapes, but never to such aesthetic effect. Wouverman was a master of composition, and in his mature work he achieved a complete integration of landscape and figures to a degree not realized by other Dutch landscape painters.

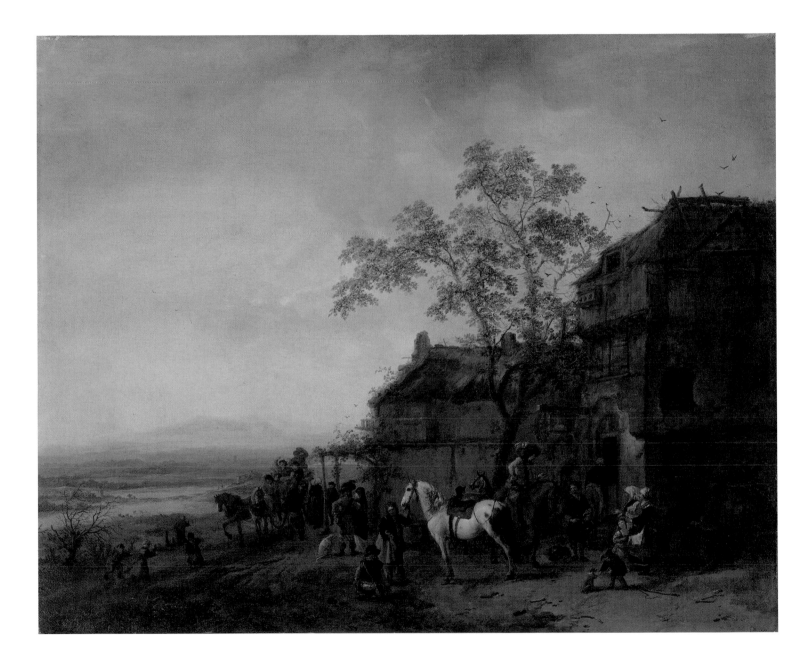

THOMAS WIJCK

Dutch, 1616–1677

Thomas Wijck lived in Haarlem where he joined the Guild of St. Luke in 1642. The major part of his oeuvre consists either of views of Southern ports or Italian street scenes. He was influenced by two Italianate Haarlem artists, Pieter van Laer (called Bamboccio) and Nicolaes Berchem (q.v.). Although the subject matter of Wijck's paintings suggests a stay in Italy, there is no documentary evidence to confirm this.

46. Street Vendors in a Southern Port

Signed lower left: *TWyck*
Canvas, 60 × 71 cm
Jakob Briner Foundation, Winterthur
Provenance: Collection Toppin; Galerie Fischer, Luzern, auction 18 June 1977, no. 397 and auction 23 May 1985, no. 1450; acquired at auction 1985
Literature: Wegmann 1986, pp. 28–29

The imaginary harbor scene is suggestive of the coast of Genoa or Naples, or possibly Livorno, where the Dutch had many shipping interests. Against a backdrop of massive buildings, street vendors display their wares. A richly dressed oriental merchant, wearing a large turban, presides over the scene. An elegant lady, accompanied by her maid, who holds a sunshade, approaches from behind. A few Dutch traders and a galley slave complete the group on the left. On the right a view opens into the distance to give a glimpse of the sea.

The outdoors genre scene, bathed in warm sunlight, and the compositional structure of the painting are derived from Pieter van Laer,[1] but the elegance and oriental character of some of the figures show the influence of Nicolaes Berchem (q.v.). This is one of the masterpieces of the Dutch Italianate school of painting, justifying Stechow's claim that Wijck is an underrated artist.[2]

1. Compare *The Cake Vendor* by Pieter van Laer, Rome, Galleria Nazionale (Rosenberg/Slive/ter Kuile 1966, fig. 152a).

2. Stechow 1966/68, p. 217, n. 67. Compositions similar to the Briner painting are in Budapest, Munich (Schloss Schleissheim) and in a private collection (see Salzburg/Vienna 1986, no. 80).

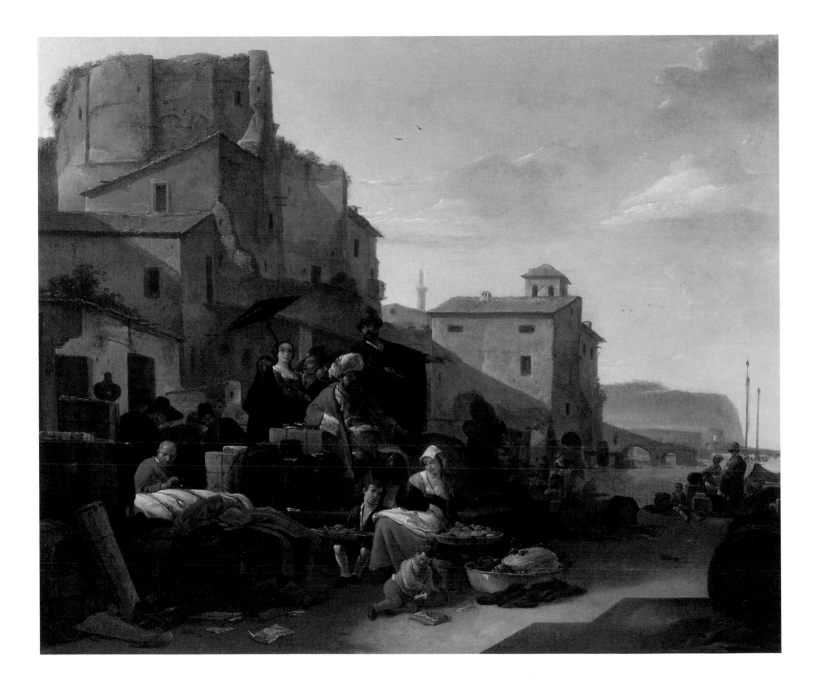

Samuel Hofmann

Swiss, 1595–1649

S amuel Hofmann was born in Sax near St. Gallen, the son of a parson. From 1608 to 1611 he trained with the Zurich painter Gotthard Ringgli (1575–1635). From 1614/15 to 1622 he was in Amsterdam and he married an Amsterdam woman in 1622. Sandrart reports that Hofmann "made his name with many pictures which he painted in Amsterdam", but none of these works is known. Hofmann returned with his wife to Zurich in 1622 and became the city's most renowned portrait painter. The year 1626 saw the foundation of the municipal library of Zurich, to which a Kunstkammer was attached. The town's dignitaries, on assuming their positions, would have their portraits painted; these they then bequeathed to the Kunstkammer. Portrait commissions were thus readily available in Zurich, but Hofmann also painted portraits elsewhere. He spent some time in the army camps along the Upper Rhine, where he painted various commanders involved in the Thirty Years War. In 1643/44 Hofmann was in Basel, and from 1644 until his death he lived and worked in Frankfurt am Main as a sought-after portraitist. Hofmann's oeuvre includes a small number of still lifes that are more Flemish than Dutch in character, a stylistic characteristic that can be explained by the large number of Flemish paintings in Amsterdam in the early seventeenth century. Hofmann's portrait style, though conventional, shows an acquaintance with portraits by Frans Hals, particularly the officers' groups from c. 1616.

47. Portrait of Andreas Steiner

Inscribed and signed upper right:
AETATIS SUAE.49.ANNO.1634/HOFMAN.FO
Inscription along the base: *Herr Andereas Steiner, ward Schulthess ANO 1638. Starb A° 1651*
Canvas, 77 × 64 cm
Kunstmuseum, Winterthur, inv. no. 620
Provenance: Donated by Steiner's heirs to the Civic Library of Winterthur in 1666; City of Winterthur, on loan to the Kunstmuseum, Winterthur, since 1932 (inv. no. 620)
Literature: Schlégl 1980, cat. no. 33, pp. 32, 34, 56, 59

The subject of this portrait, Andreas Steiner (1585–1651), was town captain in 1634, the year of the painting, and later became *Schultheiss* (mayor) of the city of Winterthur. He was the son of a prosperous family of salt traders, and according to tradition he received his military training in the Netherlands. Steiner commanded the Winterthur troop of the Zurich regiment during the campaign in the Veltlin in

1620, when Protestant forces from Zurich and Berne came to the aid of the Bündner protestants in the Thirty Years War. Steiner remained active in his military position until, in 1638, he was appointed *Schultheiss.* As mayor he led the city's troop of 214 infantry and twelve cavalry soldiers to join the Zurich military force during the peasant revolt of 1646. In 1651, while convalescing in Baden, he died of a stroke.

Hofmann portrayed Steiner in his military armor, in a half-length pose suggesting the Dutch tradition of officers' portraits by Jan Anthonisz van Ravesteyn, Michiel van Miereveld, or Frans Hals. The expressive features, framed by bushy hair and beard, are well characterized. The voluminous figure, filling most of the picture space, creates an impressive presence suggesting authority and *gravitas.*

The inscription on a painted band along the picture base was probably added in 1666 when the picture was donated to the civic library of Winterthur.

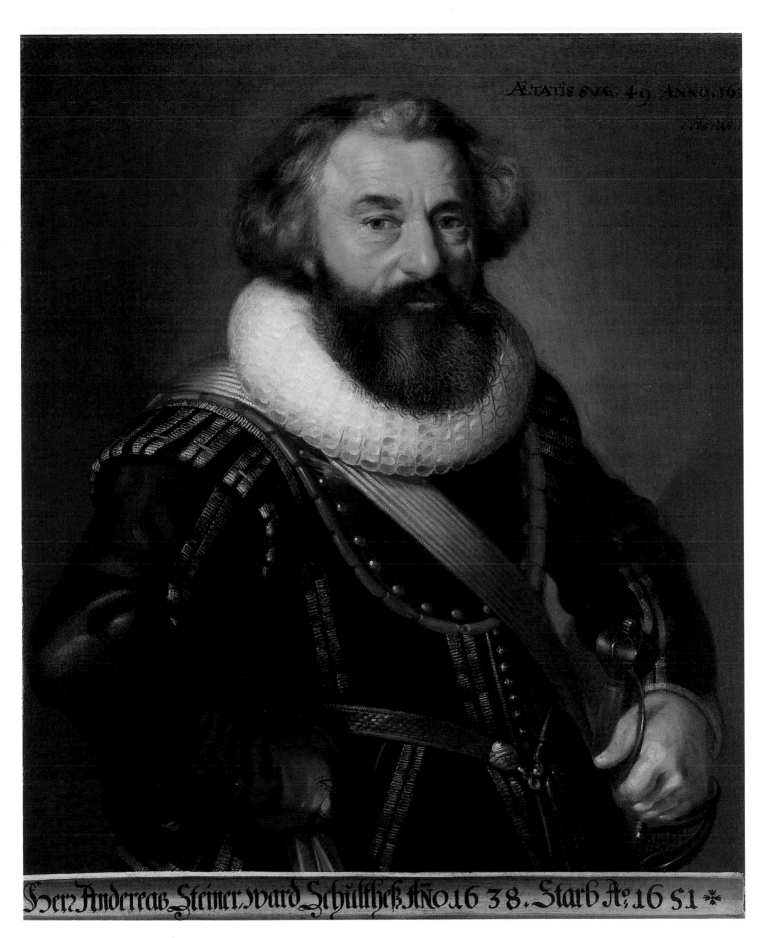

ÆTATIS SVÆ 49 ANNO 16..

Herr Andereas Steiner ward Schultheß Aᴺᴼ 16 3 8. Starb Aᴼ 16 51 ✳

SAMUEL HOFMANN

48. Portrait of an Officer

Signed on the commander's baton: *HOFMAN-FECIT.*
Inscribed upper left: *AETATIS SVAE.32.ANNO 1638*
Canvas, 91.5 × 72.5 cm
Kunstmuseum, Winterthur, inv. no. 117 (legacy Studer)
Provenance: Collection Antistes Veith, Schaffhausen, 1835; Dr. J.J. Studer, Winterthur, 1865
Literature: Schlégl 1980, cat. no. 49, p. 56
Exhibition: Bern 1936, no. 78

This is one of Hofmann's most successful officer portraits, particularly noticeable for the delicate tonal harmony of the red-brown color nuances set against grey shadows and bathed in a warm yellow light. The peculiar twist of the sitter's right hand holding the baton, and the sharp foreshortening of the right arm are reminiscent of the central foreground figure in Frans Hals's *Banquet of the Officers of the Haarlem Militia Company of St. George* (Haarlem, Frans Hals Museum), dated 1616, which Hofmann could easily have seen during his stay in Holland. Hofmann must have executed this portrait in one of the military camps on the Upper Rhine where he painted pictures of high ranking officers c. 1638. The baton and the chain worn by the sitter indicate that he probably held the rank of a colonel or above.

SAMUEL HOFMANN

49. *Portrait of a Zurich Woman*

Panel, 68 × 57 cm
Geneva, Musée d'Art et d'Histoire, inv. no. CR. 75
Provenance: Legacy Gustave Revilliod, Geneva, 1890
Literature: Deonna 1938, no. 75; Hautecoeur 1948, p. 40; Schlégl 1980, cat. no. 40
Exhibition: Geneva 1943, no. 640

The details of the Zurich costume and the ruff worn by the sitter indicate a date of c. 1635. Hofmann painted a series of portraits of Zurich ladies that are stylistically close to the painting here discussed. The naturalism and restraint of the composition, again, point to Dutch sources, but the freshness and quiet charm of the sitter are peculiarly Swiss. The carnation in the lady's hand is a traditional symbol of betrothal, often seen in Dutch portraits of young women.

FELIX MEYER

Swiss, 1653–1713

Felix Meyer was born in Winterthur and trained in 1668 with the German portrait painter Balthasar Krieger in Nuremberg. He continued his training there with the landscape painter Franz Ermels, since landscape was more to his liking. After his return to Winterthur he continued his relationship with Ermels and was on friendly terms with the German landscape painter Johann Heinrich Roos. From c. 1699 to 1703 he was active in Berne. In 1703 he painted thirty-two pictures representing "natural phenomena", mostly views of the Alps, commissioned by Count Luigi Ferdinando Marsigli, a leading natural scientist and professor in Bologna. The Zurich natural scientist Johann Jakob Scheuchzer inspected these paintings in 1704, making corrections and copying some of them for his own studies. In 1707 Meyer executed landscape frescos in the Augustinian Monastery of St. Florian in Austria. His paintings did not bring him financial success and in 1708 he accepted the position of custodian at the Castle Wyden in Switzerland, where he died. Meyer's landscape style was initially influenced by his German painter friends Franz Ermels, Willem van Bemmel, and Johann Heinrich Roos, who followed the example of Dutch Italianate painters, such as Nicolaes Berchem, Jan Both, Jan Hackaert, Frederick de Moucheron, and Johannes Glauber. He made copies after prints of these artists' works, and also of Roman landscapes by Claude Lorrain, Nicolas Poussin, and Salvator Rosa. His etchings reflect the ideal-landscape type created by these artists. In many of his paintings, however, Meyer tried to render topographically correct vistas of the Swiss landscape. According to Füssli he made many excursions into the high mountains where he made sketches from nature. These attempts seem to have been inspired by the landscape drawings made by Hackaert and Conrad Meyer during their joint Alpine journey in 1655. Although Conrad Meyer was not Felix's father (as erroneously stated by Gerson, 1942), the two artists undoubtedly knew each other and Felix was familiar with Conrad's work. While drawings of the high Alpine regions had been made by earlier artists, Felix Meyer was the first to represent these views in painting.

50. The Lower Grindelwald Glacier

Canvas, 56 × 76 cm
Kunstmuseum, Winterthur, inv. no. 1125
Provenance: Almost certainly the *Grindelwaldgletscher* by Felix Meyer owned by the Civic Library, located in the Town Hall of Winterthur. The painting was lost during building restorations in 1782. Acquired in 1971 by the City of Winterthur from a private collection, and deposited in the Kunstmuseum Winterthur.
Literature: Zumbühl 1980, pp. 21–23, 131 (records the older literature)

This view of the Lower Grindelwald Glacier in the Bernese Oberland is the earliest known oil painting representing a Swiss glacier. It includes recognizable views of the Mettenberg Mountain on the left, the Untere Schopf, and the ice-filled Lütschinen Ravine in the right foreground, which today is narrower than shown in the painting. The focus of the composition is an ice-grotto, one of the natural phenomena that fascinated Meyer's contemporaries. The grotto is surrounded by admiring sightseers whose tiny figures emphasize the vast scale of the surrounding mountain scenery. The figure of an artist sketching in the left foreground may well be intended as a self-portrait, in the tradition of many Northern landscape artists who liked to demonstrate their personal observation of nature. Also within the Northern landscape tradition is the manner in which Meyer has combined observed topographical motifs with imaginary elements. The mountain peak emerging from a bank of clouds in the upper left, for instance, has been added to the scene to dramatize the massive scale of the setting, much as Jacob van Ruisdael did when he included a similar mountain in a painting in the Hermitage, Leningrad (HdG 155), currently on view at the Pushkin Museum. The Winterthur painting probably belongs to the artist's late period in Berne (c. 1699–1703), when the Bernese painter Johannes Dünz made a portrait of Meyer (now known only from a print) in his studio, with a similar Alpine landscape on the easel (see p. 24 in this catalogue).

SELECTED BIBLIOGRAPHY

Allen 1987
Eva Jeney Allen. *The Life and Art of Pieter de Molijn*. International, Ann Arbour, Michigan, 1987

Amsterdam 1976
Tot lering en vermaak. Rijksmuseum Amsterdam. 1976. Catalogue by E. de Jongh et al.

Amsterdam/Zwolle 1982
Hendrick Avercamp, Barent Avercamp: Frozen Silence. Amsterdam, Waterman Gallery, and Zwolle, Provinciaal Overijssels Museum. 1982

Amsterdam/Emden 1985
Ludolf Bakhuizen. Amsterdam, Nederlands Scheepvaart Museum, and Emden, Museum. 1985

Amsterdam/Boston/Philadelphia 1987/88
Masters of 17th-Century Dutch Landscape Painting. Rijksmuseum Amsterdam; Museum of Fine Arts, Boston; Philadelphia Museum of Art. 1987/88. Catalogue by Peter C. Sutton et al.

Baines 1966
Anthony Baines. *European and American Instruments*. London, 1966

Basel 1987
Im Lichte Hollands. Holländische Malerei des 17. Jahrhunderts aus den Sammlungen des Fürsten von Liechtenstein und aus Schweizer Besitz. Kunstmuseum Basel. 1987

Beck 1972/73
Hans-Ulrich Beck. *Jan van Goyen, 1596–1656*. 3 vols. Amsterdam, 1972/73 (3rd vol. 1988)

Bern 1943
Holländische und Vlämische Meister des 16. und 17. Jahrhunderts. Kunstmuseum Bern. 1943

Bernt 1969/70
Walther Bernt. *Die niederländischen Maler des 17. Jahrhunderts*. Munich, 1969/70

de Bie 1661
Cornelis de Bie. *Het gulden cabinet*. Antwerp, 1662

Bille 1961
Clara Bille. *De Tempel der kunst of het kabinet van den Heer Braamkamp*. 2 vols. Amsterdam, 1961

Bol 1969
Laurens J. Bol. *Holländische Maler des 17. Jahrhunderts nahe den grossen Meistern: Landschaften und Stilleben*. Braunschweig, 1969

Bol 1973
Laurens J. Bol. *Die holländische Marinemalerei des 17. Jahrhunderts*. Braunschweig, 1973

Bregenz 1984
Die Schweizer Ansichten 1653–1656 von Jan Hackaert. Vorarlberger Landesmuseum, Bregenz. 1984. Catalogue by Gustav Solar

Brière-Misme 1927
Clotilde Brière-Misme. *Tableaux inédits ou peu connus de Pieter de Hooch*. Parts I–III. Gazette des Beaux-Arts, June, July/August, November 1927

Brochhagen 1958
Ernst Brochhagen. *Karel Dujardin: Ein Beitrag zum Italianismus in Holland im 17. Jahrhundert*. Dissertation. Cologne, 1958

Broulhiet 1938
Georges Broulhiet. *Meindert Hobbema*. Paris, 1938

Brulhart 1978
Armand Brulhart. *La peinture hollandaise dans les collections privées de Genève au XVIIIe et au XIXe siècle et le Catalogue des tableaux hollandais du Musée d'art et d'histoire de Genève*. Dissertation. Geneva, 1978 (unpublished)

Burke 1976
James D. Burke. *Jan Both: Paintings, Drawings and Prints*. Dissertation. Harvard, 1972. New York, 1976

Der Cicerone
Der Cicerone. Halbmonatsschrift für Künstler, Kunstfreunde und Sammler. Leipzig

DaCosta Kaufmann 1985
Thomas DaCosta Kaufmann. *L'école de Prague. La peinture à la cour de Rodolphe II*. Paris, 1985

Dattenberg 1967
Heinrich Dattenberg. *Die Niederrheinansichten holländischer Künstler des 17. Jahrhunderts*. Düsseldorf, 1967

Delft 1953
Vijftig werken uit de collectie Baszanger te Genève. Stedelijk Museum "Het Prinsenhof", Delft. 1953

Deonna 1943
Waldemar Deonna. *Le Legs Guillaume Favre au Musée d'Art et d'Histoire de Genève*. Geneva, 1943

Dublin 1872
Dublin Exhibition. 1872

Edinburgh 1984
Dutch Church Painters. National Gallery of Scotland, Edinburgh. 1984

Ertz 1979
Klaus Ertz. *Jan Brueghel d.Ä. (1568–1625): Die Gemälde*. Cologne, 1979

Franz 1969
Heinrich Gerhard Franz. *Niederländische Landschaftsmalerei im Zeitalter des Manierismus*. 2 vols. Graz, 1969

Garlick 1974–76
K.J. Garlick. *Pictures of Althorp*. Walpole Society, London, 1974–76.

de Geer 1915
Baron de Geer. *Nos Anciens et leurs oeuvres*. Geneva, 1915

Geneva 1954
Trésors des collections romandes. Musée Rath, Geneva. 1954

Geneva 1955
Cent Tableaux de la Collection Baszanger. Musée d'Art et d'Histoire de Genève. 1955

Gerson 1942
Horst Gerson. *Ausbreitung und Nachwirkung der holländischen Malerei des 17. Jahrhunderts*. Haarlem, 1942. Reprint Amsterdam, 1983

Gielly 1928
Louis Jules Gielly. *Catalogue des peintures et sculptures*. Musée d'Art et d'Histoire, Genève. Geneva, 1928

Glück 1907
Gustav Glück. *Niederländische Gemälde aus der Sammlung des Herrn Alexander Tritsch*. Wien, 1907

Granberg 1911
Olof Granberg. *Inventaire Général des Trésors d'Art, peintures et sculptures, principalement de maîtres étrangers (non scandinaves) en Suède*. 2 vols. Stockholm, 1911

Grant 1956
Maurice H. Grant. *Rachel Ruysch*. Leigh-on-Sea, 1956

Greindl 1983
Edith Greindl. *Les peintres flamands de nature morte au 17e siècle*. Stenebeek, 1983

Haak 1984
Bob Haak. *The Golden Age: Dutch Painters of the Seventeenth Century*. New York, 1984

The Hague/London 1970/71
Shock of Recognition: The Landscape of English Romanticism and the Dutch Seventeenth-Century School. Mauritshuis, The Hague/Tate Gallery, London. 1970/71

Hautecoeur 1948
Louis Hautecoeur. *Catalogue de la Galerie des Beaux-Arts*. Geneva, 1948

Haverkamp Begemann 1978
Egbert Haverkamp Begemann. *Wadsworth Atheneum Paintings, Catalogue I*. Hartford, 1978

Hind 1915–31
Arthur M. Hind. *Catalogue of Drawings by Dutch and Flemish Artists in the British Museum*. 4 vols. London, 1915–31

Hofstede de Groot 1907–28
Cornelis Hofstede de Groot. *Beschreibendes und kritisches Verzeichnis der Werke der hervorragendsten holländischen Maler des XVII. Jahrhunderts*. 10 vols. Esslingen a.N./Paris/London, 1907–28

Houbraken 1718–21
Arnold Houbraken. *De groote schouburgh der Nederlantsche konstschilders en schilderessen*. 3 vols. Amsterdam, 1718–21. 2nd printing, Amsterdam, 1753. Reprint 1976

Jaffé 1977
Michael Jaffé. *Rubens and Italy*. Oxford 1977

Jantzen 1910
Hans Jantzen. *Das Niederländische Architekturbild*. Leipzig, 1910. Reprint Braunschweig, 1979

Keyes 1984
G. S. Keyes. *Esaias van de Velde, 1587–1630*. Dornspijk, 1984

Lasius 1987
Angelika Lasius. *Quirijn van Brekelenkam*. Dissertation. Göttingen, 1987

Liedtke 1982
Walter A. Liedtke. *Architectural Painting in Delft: Gerard Houckgeest, Hendrick van Vliet, Emanuel de Witte*. Dornspijk, 1982

Manchester 1857
Art Treasures. Manchester, 1857

de Mandach 1905
S. de Mandach. *La collection de Léopold Favre*. Les Arts 4, April 1905, pp. 2–9

Manke 1963
Ilse Manke. *Emanuel de Witte, 1617–1692*. Amsterdam, 1963

Müllenmeister 1988
Kurt J. Müllenmeister. *Roelant Savery (1576–1639). Die Gemälde mit kritischem Oeuvrekatalog*. Freren, 1988

Neuchâtel 1953
Semaine hollandaise. Musée des Beaux-Arts, Neuchâtel, 1953

Oldenbourg 1911
R. Oldenbourg. *Thomas de Keysers Tätigkeit als Maler*. Leipzig, 1911

Österreichische Kunsttopographie 1908
Die Gemäldesammlung des Felix Koranda in Wien. Österreichische Kunsttopographie. Vol. II. 1908

Philadelphia/Berlin/London 1984
Masters of the Seventeenth-Century Dutch Genre Painting, from Frans Hals to Vermeer. Meisterwerke holländischer Genremalerei. Philadelphia Museum of Art, Philadelphia / Gemäldegalerie Staatliche Museen Preussischer Kulturbesitz, Berlin / Royal Academy of Arts, London. 1984

Pigler 1956
A. Pigler. *Barockthemen. Eine Auswahl von Verzeichnissen zur Ikonographie des 17. und 18. Jahrhunderts.* 3 vols, 1st ed. Berlin and Budapest, 1956. Reprint Budapest, 1974

Réau 1950
Louis Réau. *Les Maîtres Anciens de la Collection Baszanger.* Geneva: Mont Blanc, [1950]

Reinle 1952
Adolf Reinle. *Marsigli und die Kunst in der Schweiz.* Zeitschrift für Schweizerische Archäologie und Kunstgeschichte 13 (1952), pp. 175ff.

Renger 1986
Konrad Renger. *Adriaen Brouwer und das niederländische Bauerngenre 1600–1660.* Munich, 1986

Rigaud 1876
J.-J. Rigaud. *Renseignements sur les Beaux-Arts à Genève.* Geneva, 1876

Robinson 1973/74
M. S. Robinson. *Van de Velde Drawings: A Catalogue of Drawings in the National Maritime Museum Made by the Elder and the Younger van de Velde.* 2 vols. Cambridge, 1973/74

Robinson (forthcoming)
M. S. Robinson. *The Paintings of Willem van de Velde the Elder and the Younger.* National Maritime Museum (forthcoming)

Rome/Milan 1954
Mostra di Pittura Olandese del Seicento. Palazzo delle Esposizioni, Rome / Palazzo Reale, Milan. 1954

Rosenberg / Slive / ter Kuile 1966
Jakob Rosenberg / Seymour Slive / E. H. ter Kuile. *Dutch Art and Architecture, 1600–1800.* Harmondsworth, 1966

Rotterdam 1979
The Willem van de Velde Drawings in the Boymans-van Beuningen Museum. 3 vols. Museum Boymans-van Beuningen Foundation, Rotterdam. 1979

Russell 1975
Margarita Russell. *Jan van de Capelle, 1624/26–1679.* Leigh-on-Sea, 1975

Russell 1983
Margarita Russell. *Visions of the Sea: Hendrik C. Vroom and the Origins of Dutch Marine Painting.* Leiden, 1983

Salzburg/Vienna 1986
Die Niederländer in Italien. Italianisante Niederländer des 17. Jahrhunderts aus Österreichischem Besitz. Residenzgalerie Salzburg / Gemäldegalerie der Akademie der bildenden Künste, Wien. 1986. Catalogue by Renate Trnek.

Sandrart 1675
Joachim von Sandrart. *L'Academia Todesca della Architectura, Scultura et Pictura: Oder Teutsche Academie der Edlen Bau-, Bild- und Mahlerey-Künste [...].* Nürnberg, 1675

Schlégl 1980
István Schlégl. *Samuel Hofmann (um 1595–1649).* Zurich/Munich, 1980

Schnackenburg 1981
Bernhard Schnackenburg. *Adriaen van Ostade, Isaack van Ostade. Zeichnungen und Aquarelle. Gesamtdarstellung mit Werkkatalogen.* 2 vols. Hamburg, 1981

Schneeman 1982
Liane T. Schneeman. *Hendrick Maertensz Sorgh: A Painter of Rotterdam.* Dissertation. The Pennsylvania State University. 1982

Schulz 1982
Wolfgang Schulz. *Herman Saftleven (1609–1685).* Berlin, 1982

von Sick 1930
Ilse von Sick. *Nicolaes Berchem, ein Vorläufer des Rokoko.* Berlin, 1930

Six 1919
J. Six. *Bevestigde overlevering.* Oud Holland 37 (1919), pp. 80–86

Sluijter-Seijffert 1984
Nicolette Sluijter-Seijffert. *Cornelis van Poelenburch, ca. 1593–1667.* Dissertation. Leiden, 1984

Smith 1829–42
John Smith. *A Catalogue Raisonné of the Works of the Most Eminent Dutch, Flemish and French Painters.* 8 vols. and Supplement. London, 1829–42

Solar 1978
Gustav Solar. *Conrad Meyer und Jan Hackaert. Feststellungen um einen Fund.* Beiträge zur Kunst des 17. und 18. Jahrhunderts in Zürich. Jahrbuch 1974–1977 des Schweizerischen Instituts für Kunstwissenschaft. Zurich, 1978

Solar 1981
Gustav Solar. *Jan Hackaert. Die Schweizer Ansichten 1653–1656. Zeichnungen eines niederländischen Malers als frühe Bilddokumente der Alpenlandschaft.* Ed. by Zentralbibliothek Zürich und Schweizerisches Institut für Kunstwissenschaft. Dietikon/Zurich, 1981

Solar 1984
Gustav Solar. *Zur Datierung von Jan Hackaerts Rheinfall-Ansichten.* Schaffhauser Beiträge zur Geschichte 61 (1984), pp. 229–40

Stadler 1986
Barbara Stadler. *Die Bildnisminiaturen der Sammlung Jakob Briner Winterthur.* Winterthur, 1986

Stechow 1966
Wolfgang Stechow. *Dutch Landscape Painting in the Seventeenth Century.* New York, 1966

Steland-Stief 1971
Anne Charlotte Steland-Stief. *Jan Asselijn, nach 1610–1652.* Amsterdam, 1971

Steland-Stief 1980
Anne Charlotte Steland-Stief. *Zum zeichnerischen Werk des Jan Asselijn.* Oud Holland 94 (1980), pp. 213–58

Stelling-Michaud 1937
Sven Stelling-Michaud. *Unbekannte Schweizer Landschaften aus dem XVII. Jahrhundert. Zeichnungen und Schilderungen von Jan Hackaert und anderen holländischen Malern.* Zürich/Leipzig, 1937

Sutton 1980
Peter C. Sutton. *Pieter de Hooch.* Complete edition with a Catalogue raisonné. Ithaca, 1980

Valentiner 1929
Wilhelm R. Valentiner. *Pieter de Hooch. Des Meisters Gemälde.* Stuttgart/Berlin/Leipzig, 1929

Vroom 1980
N. R. A. Vroom. *A Modest Message as Intimated by the Painters of the "Monochrome Banketje".* 2 vols. Schiedam, 1980

Waagen 1854
Gustav Friedrich Waagen. *Treasures of Art in Great Britain.* 3 vols. London, 1854

Weber 1974
Bruno Weber. *Der Zürichsee von Jan Hackaert.* Zeitschrift für Schweizerische Archäologie und Kunstgeschichte 31 (1974), pp. 230–41

Weber 1979
Bruno Weber. Graubünden in alten Ansichten. Chur, 1984

Wegmann 1986
Peter Wegmann. *Stiftung Jakob Briner, Rathaus Winterthur: Neuerwerbungen 1971–1986.* Winterthur, 1986

Wegmann (forthcoming)
Peter Wegmann. *Katalog der Gemälde der Stiftung Jakob Briner.* Winterthur (forthcoming)

Welcker 1933
Clara J. Welcker. *Hendrick Averkamp (1585–1634), bijgenaamd "De Stomme van Campen" en Barent Averkamp (1612–1679), "Schilders tot Campen".* Zwolle, 1939. Revised edition by D.J. Henbroek-van der Poel. Dornspijk, 1979

Wheelock 1975/76
Arthur K. Wheelock. *Gerard Houckgeest and Emanuel de Witte: Architectural Painting in Delft around 1650.* Simiolus 8 (1975/76), Nr. 3

Wheelock 1977
Arthur K. Wheelock. *Perspective, Optics, and Delft Artists around 1650.* New York / London, 1977

Wheelock 1986
Arthur K. Wheelock. *Review of Liedtke 1982.* The Art Bulletin, March 1986, Vol. LXVIII, Nr. 2

Wiegand 1971
Wilfried Wiegand. *Ruisdael-Studien. Ein Versuch zur Ikonologie der Landschaftsmalerei.* Dissertation. Hamburg, 1971

Zimmermann 1908
Max G. Zimmermann. *Niederländische Bilder des 17. Jahrhunderts in der Sammlung Hölscher-Stumpf.* Leipzig, 1908

Zumbühl 1980
Heinz J. Zumbühl. *Die Schwankungen der Grindelwaldgletscher in den historischen Bild- und Schriftquellen des 12. bis 19. Jahrhunderts.* Basel, 1980

Zurich 1947
Meisterwerke aus vier Jahrhunderten. Galerie Neupert, Zurich. 1947

Zurich 1953
Holländer des 17. Jahrhunderts. Kunsthaus, Zurich. 1953

© 1989

The Jakob Briner Foundation, Winterthur
Board of Trustees: Professor Dr. Franz Zelger, Dr. Martin Haas,
Dr. Peter Wegmann

Translations: Annemarie Jordan, Margarita Russell
Assistant: Matthias Wohlgemuth

Photographs: Musée d'Art et d'Histoire, Geneva; Hans Humm,
Zürich; Swiss Institute for Art Research, Zürich; Sammlung Oskar
Reinhart "Am Römerholz", Winterthur; Stadtbibliothek Winterthur

Lithography by Seba Clichés AG, Zürich
Typeset by FoRep AG, Uster
Printed by Sigg Söhne AG, Winterthur

Cover illustration: cat. no. 11

ISBN 3-907798-01-5

Made in Switzerland